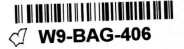

W9-BAG-406

THE
WORLD
TRADE
CENTER
REMEMBERED

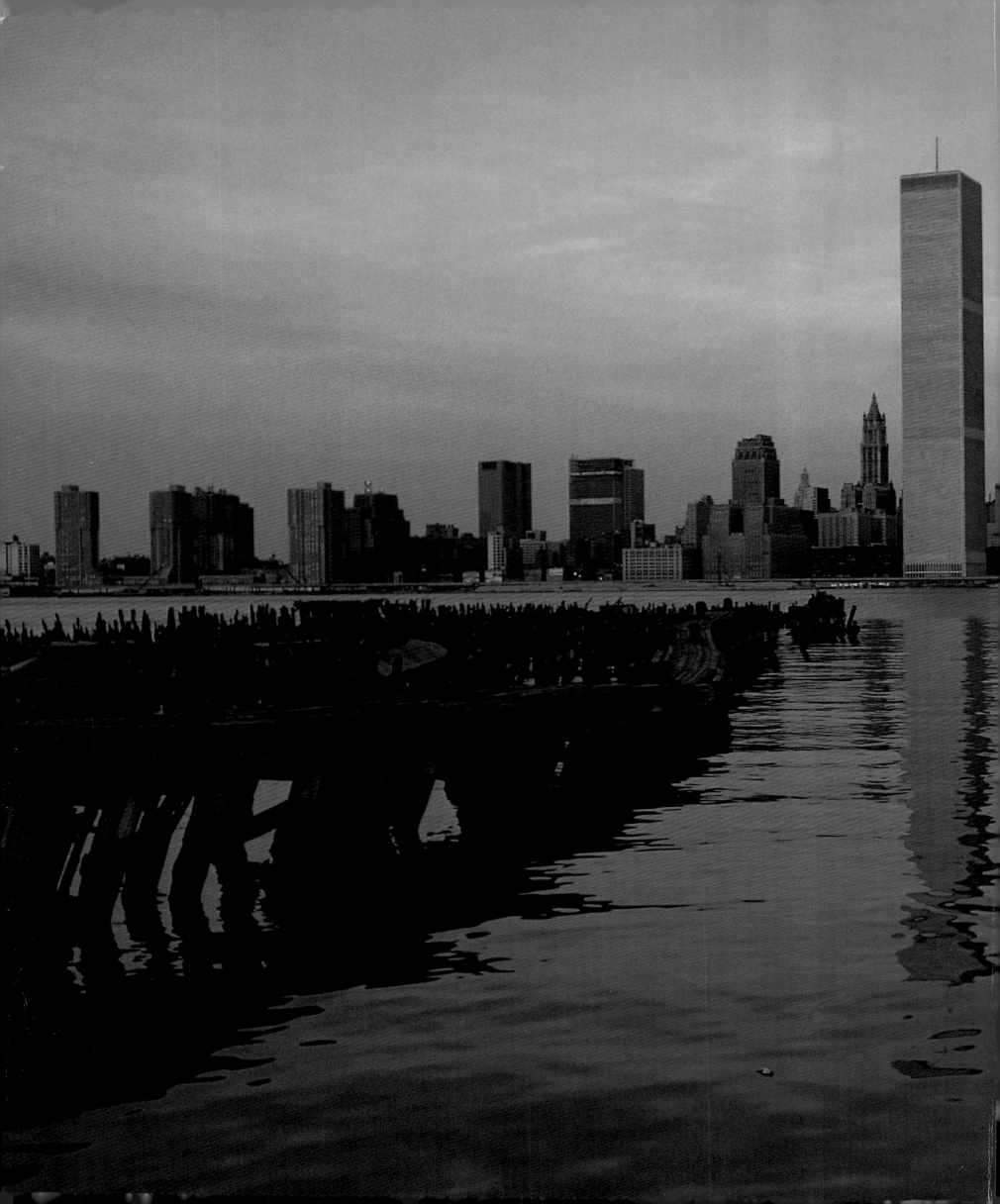

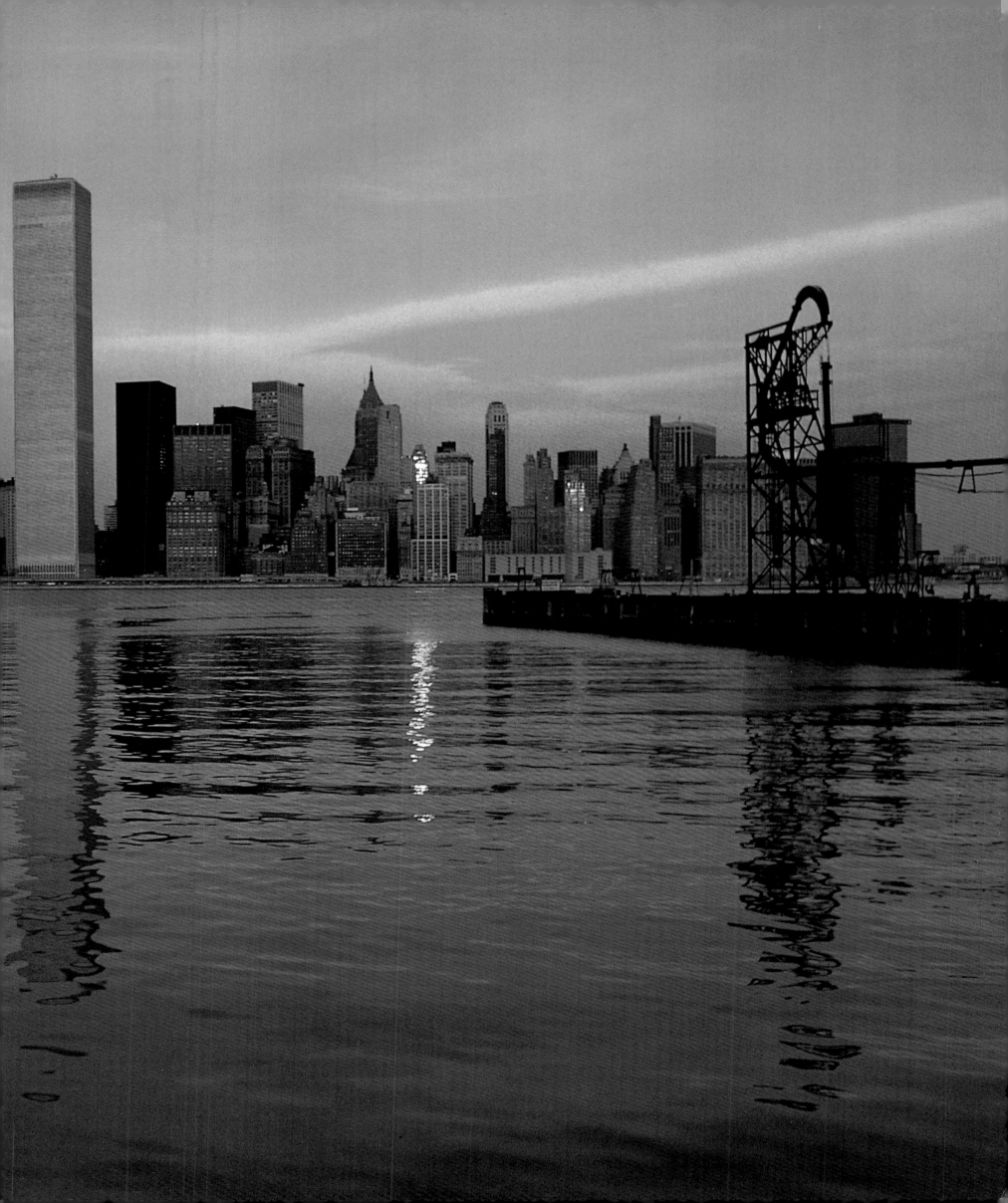

THE
WORLD
TRADE
CENTER
REMEMBERED

PHOTOGRAPHS BY
SONJA BULLATY AND ANGELO LOMEO

TEXT BY
PAUL GOLDBERGER

ABBEVILLE PRESS
PUBLISHER

NEW YORK LONDON

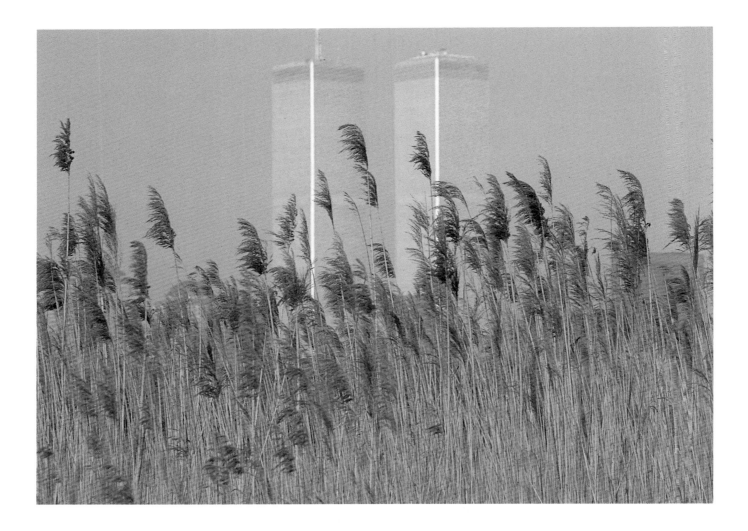

PHOTOGRAPHER'S DEDICATION

I dedicate this book to Sonja Bullaty my wife and partner, who gave me fifty beautiful years of love and togetherness that I will treasure within my heart for the rest of my life. Sonja died on October 5, 2000, after a long and painful battle with cancer.

It was through Sonja's love for New York City and our persistence that this collection of photographs of the World Trade Center—taken from every direction and spanning its twenty-eight year history—came to be. As we traveled through the city, we always noticed the towers, standing gloriously tall and appreciated its presence welcoming us back after a flight from out west.

The towers were more than buildings; they stood for the greatness of New York City and America. And I believe the World Trade Center will be rebuilt, proving that terrorists cannot destroy the American spirit of freedom and democracy.

These photographs are a testament to our great city and a record of a time gone by that will never be forgotten. I believe the victims of the World Trade Center did not die as they will live within our hearts forever.

Angelo Lomeo

CONTENTS

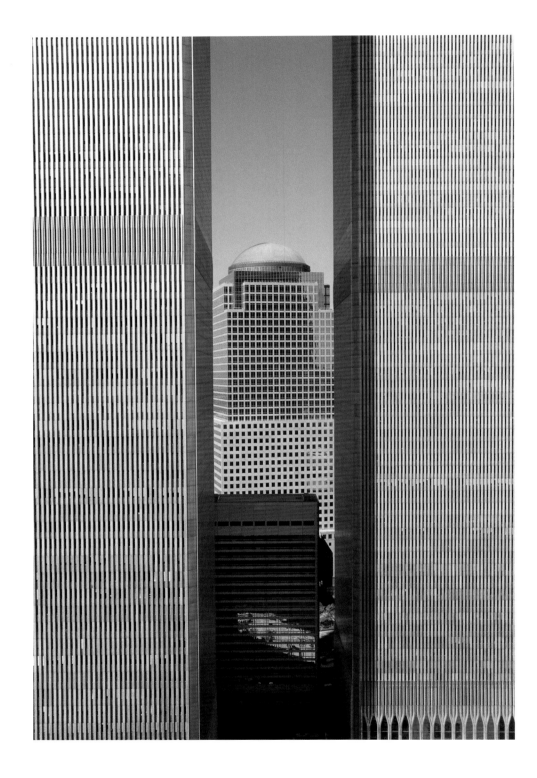

PUBLISHER'S PREFACE

A panoramic view of the World Trade Center towers was a constant presence for the staff of Abbeville Press, through the west windows of its offices across Church Street from the splendid plaza at the center of the complex. Said to have been modeled after the piazza of St. Mark's in Venice, the plaza, seen from above, was an ever-changing kaleidoscope of human activity, from bundled-up shoppers braving a brisk wind as the holidays approached, to shirt-sleeved office workers taking lunch in the spring sun, to crowds attending summer evening concerts, which we, too, enjoyed when working late.

Abbeville Press, which has for several years occupied the thirty-second floor of the 22 Cortlandt Street building, lost its home temporarily in the aftermath of the tragic events of September 11. Like so many other thousands of businesses, we are determined to rebuild, and we look to the future. Nevertheless, we feel that the memory of what our corner of Lower Manhattan once looked like should be preserved. Like St. Mark's, or the Piazza della Signoria in Florence, the World Trade Center Plaza was a "beating heart" of the city. In our time it was—and will become again—the center of a global economic network. It is not merely the symbol of this country's economic power, as our enemies perceive it, but much more: the embodiment of our role as an engine of local, national, and global prosperity.

But symbols don't create markets; they don't establish the essential underpinnings of a world economy that offers hope and the possibility of economic development to millions of people in countries far from Liberty Street. People do that, and they included the thousands who lost their lives on September 11, 2001, whose company we enjoyed every day. This book is thus dedicated to the victims of the World Trade Center attacks and their families and colleagues.

Robert E. Abrams

THE WORLD TRADE CENTER: RISING IN SHEER EXALTATION

PAUL GOLDBERGER

"Nothing better reveals the linkages made,
sometimes unconsciously,
between building and human life cycles than the powerful emotions
raised by the expiration of a structure's
time on earth."

—Neil Harris, *Building Lives,* 1999

It is necessary to begin with September 11, even as we yearn to go back before that day, because everything about the World Trade Center will always be seen in the context of the cataclysmic events of that morning. Every photograph of the trade center towers, if it is not a horrific view of their destruction, is a poignant reminder of what has been lost. Every view of the towers in the soft light of dawn or the rich, deep light of evening has the urgency of real time; we know now that the sun has already moved on, and it will not come again.

Great skyscrapers do not disappear, and nothing in our experience prepares us for the void that now exists in Lower Manhattan. We describe this void, in part, as standing for the collective total of lives lost when the towers were attacked and destroyed, and of course this is true, but there is more to it than that. The void is a thing unto itself, powerful and terrifying. When it became a part of Lower Manhattan, suddenly emptiness took on more weight than fullness. The void loomed larger than the solid thing it replaced. The skyline had more magnetic power than ever before, but this time it was not the allure of the postcard view, but the horror of something ruined. Our eyes were fixed on the void not out of pleasure at the grotesque sight, but in disbelief, since before that day we had known only a skyline that grew continually bigger; it did not get smaller, and it certainly did not disintegrate.

Before September 11, the skyline functioned in the spirit of Darwinian evolution. The bigger things drove out the smaller ones. You may not have believed that the biggest buildings were truly the fittest, or that they deserved to push aside the others, but that is how things had always worked in New York, and there was no reason to believe it was going to change. Nothing ever built in the history of New York had been as tall as the towers of the World Trade Center, and there was little expectation that anything as tall as the towers would be built again. They seemed to represent a kind of culmination of the principle of survival of the fittest. They would remain, if not forever, for our lifetimes and our children's lifetimes and their children's lifetimes, of that we were certain. We may not have liked all of the buildings that had come to make up the skyline of New York by the year 2001, but we liked the skyline itself, and treasured it.

We experienced the skyline not as if it were made up of disparate parts that came together at random, but as a thing unto itself, definable and protectable. We did not think that the skyline was vulnerable, except to the risk that its delicate rhythms might be quashed by the presence of too many huge, boxy towers. To a lot of people the Darwinian principle behind the skyline's form seemed like a Faustian bargain—if you accepted the notion that the biggest buildings would prevail, you could continue being entranced

by the skyline. As the years went on, the bargain seemed more and more reasonable, since the law of the jungle was in every way the law of Manhattan. The biggest things survived, and you made a peace with that. The little buildings, the slender towers and shorter masses that once held sway over the skyline and made it such a romantic, jazzy set of rhythms, were a part of the past, and while most of them physically remained in place, their preeminence did not. That was the price you paid for the fact that the skyline was an organic thing, a living thing, that had to grow and change. As time went on there were fewer people who even remembered the skyline without the World Trade Center. To them, the skyline belonged to the tallest and there was never the slightest question what the tallest was, and so if you were young you were especially lucky, because you could never look at the New York skyline and find disappointment.

And then the strongest thing became the most fragile thing, and the whole order changed. The buildings that had symbolized the power of technology were suddenly done in by technology; the skyscrapers that had symbolized bigness and openness to the world were destroyed by the products of bigness, and by the process of openness. Of course what the towers had come to represent most of all beyond sheer size was the very idea of modernity, and everything that modernity implies: choice, transparency, possibilities,

and, most of all, the fact of constant change. These things are the modern condition, and while New Yorkers did not always feel that this aspect of their city was embodied more clearly in the World Trade Center than anywhere else, a lot of the rest of the world thought it was.

It is something of a paradox that the very things that attracted tourists to the World Trade Center—bigness, swagger, the sense that they embody the very force of capitalism— are the same things that led the terrorists to make the buildings their target. They all knew that the trade center's power was in its bigness. Build the biggest thing, and you are powerful. Visit the biggest thing, and you partake of this power. Destroy the biggest thing, and you are the most powerful of all. Both the tourists and the terrorists responded to the image of the World Trade Center in the popular imagination. It did not matter to them that the towers were not particularly admired as works of architecture, or that architecture critics often felt that the bland, simple form of the trade center made them impossible to love in the way that people seemed to love buildings like the Empire State Building and the Chrysler Building. It turned out not to be true that boxes couldn't be icons. The towers were. The two tall buildings were never officially called the Twin Towers; that was a nickname, and did the Empire State Building ever have a nickname? It was conferred on the towers by people who came from elsewhere

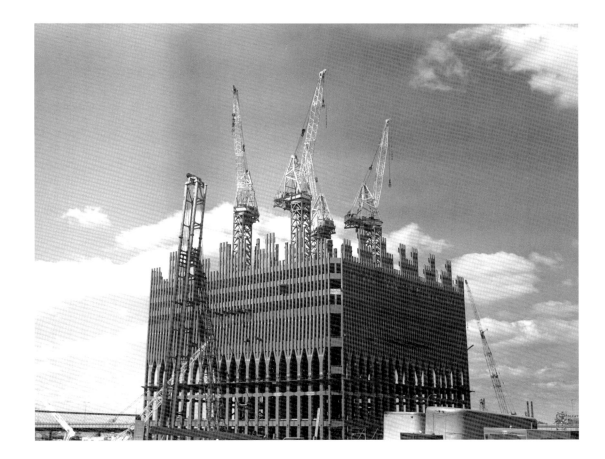

*The external wall of the towers was a steel frame
that supported the entire structure.*

and felt drawn to their hugeness, and to what they felt was an architectural expression of the greatest self-confidence imaginable.

The World Trade Center had its beginnings in the desire of two brothers—David Rockefeller, chairman of the Chase Manhattan Bank, and Nelson Rockefeller, governor of New York—to revitalize Lower Manhattan, New York's financial district, in the early nineteen-sixties. The neighborhood had faded, and the celebrated aura of Wall Street was not sufficient to keep many financial concerns from the view that greener pastures lay uptown. David Rockefeller believed in Lower Manhattan, and had already commissioned the architect Gordon Bunshaft of Skidmore, Owings & Merrill to design a new headquarters for his bank, an eight-hundred-foot slab of glass and aluminum that was finished in 1960. One Chase Manhattan Plaza stemmed the tide, but did not stop it, and it did nothing to address what were the area's real

shortcomings: a nearly total lack of housing, stores, entertainment, and almost any kind of urban amenity. Rockefeller and the Downtown–Lower Manhattan Association, the area's business group, next asked the Skidmore firm to prepare a broader plan for Lower Manhattan. Skidmore dusted off an idea that had been proposed in the late nineteen-forties and rejected for lack of demand: a complex of buildings that would house businesses dealing in international trade. There was no more certainty that the project would make sense this time, but Rockefeller liked the idea, which the Skidmore firm proposed putting on a thirteen-acre site along the East River at the east end of Wall Street. More to the point, Nelson Rockefeller liked it, too, and he asked the Port Authority, the one agency with the wherewithal to get something of this magnitude built, to study it.

The executives of the Port Authority, which operates the bridges and tunnels across the Hudson River as well as the New York airports, liked nothing better than huge projects, and they seem not to have had a moment's doubt about the scheme. Then politics intervened to make a dramatic shift in the project. The Port Authority is jointly controlled by New York and New Jersey, and to win the assent of the governor of New Jersey to the building of the trade center, the Port Authority had to agree to take over the Hudson and Manhattan Railroad, a bankrupt commuter line under the river. With the line came the Hudson Terminal, a pair of huge, shabby office buildings on the west side of Lower Manhattan, which the Port Authority preferred to demolish rather than renovate. The logical thing, the agency then concluded, was to move the trade center project west, and put it on the site of the Hudson Terminal.

When the trade center moved, the Skidmore, Owings & Merrill design no longer made sense. The Port Authority had taken over control of the project, and it selected a new architect, Minoru Yamasaki, whose work was characterized by a pair of different, even contradictory, aspects: an entrancement with technology and a fondness for romantic, often delicate forms. Yamasaki, who was based in Detroit, was a modernist who had broken away from the austerity of the International Style and tried to evolve a softer, more decorative architecture. Many of his buildings had details like neo-Gothic arches set in front of glass walls, a way to have the modernism of glass and the decoration of traditional architecture at the same time. Yamasaki's soft-edged modernism did not win much favor with critics, and he was never considered among the major design forces of the nineteen-fifties and sixties, though he was far from indifferent to design. He presented himself as an aesthete—it is just that his aesthetics only rarely seemed to appeal to the more sophisticated clients. For an agency like the Port Authority, dominated by engineers who

thought in terms of the most pragmatic, functional structures, Yamasaki represented an almost daring choice, even though much of the architectural world thought of his work as just this side of kitsch.

Yamasaki won the commission to design the World Trade Center in 1962, and he spent more than a year studying various ways of incorporating the Port Authority's demand for ten million square feet of space. He considered three and four square towers, as well as various schemes for multiple towers of different sizes, before he hit upon the notion of two identical towers, each roughly eighty stories high. Port Authority executives liked the look of this design, as Yamasaki did, but they were unhappy that it did not yield the full ten million square feet of office space that they wanted to build. They asked the architect to make the towers still higher—they were perfectly comfortable with the notion that these would be the tallest skyscrapers in the world. The towers would end up as two buildings of a hundred and ten floors each, the north tower rising to 1,368 feet, and the south tower an imperceptibly shorter 1,362 feet.

At that point, in the early nineteen-sixties, the Empire State Building was roughly thirty years old, and there was reason to expect that it would be the tallest structure in New York, and perhaps the world, forever. It made little sense to build towers much higher than the eighty stories Yamasaki had originally proposed. The problem was not engineering—structural engineers could easily produce a skyscraper twice the height of the Empire State Building, or more—but economics. Super-tall towers are astonishingly expensive. They require immense amounts of structure, and when buildings become exceedingly tall they require so many elevators that most of the space on the lower floors is taken up with elevator shafts passing through to reach the upper floors. At somewhere around eighty stories, the economics generally cease to make sense. Although the Empire State Building is technically one hundred and two floors high, its top sixteen floors are tiny spaces in the building's missile-like crown, and for practical purposes the building does not really rise higher than its eighty-sixth-floor observatory.

It was the Port Authority's own engineers who came up with a plan that would allow a taller building to make economic sense. They proposed a system in which huge express elevators would carry passengers from the ground level to "sky lobbies" one-third and two-thirds of the way up the building, after which they would transfer to local elevators to reach their own floors. The plan permitted the local elevator banks to be stacked on top of each other, occupying the same vertical space, freeing up enough space on the lower floors to make the building theoretically profitable. (The trade center did not, in fact, make much economic sense, particularly for

the first quarter century of its life, but that was for different reasons. Without the innovative elevator system it would surely not have been built at all.) The trade center system was the first significant advance in elevator design since a couple of generally unsuccessful experiments in the nineteen-thirties with double-decker elevators, which were another way of reducing the number of elevator shafts that robbed valuable space from the lower floors to provide access to the upper floors.

The other important innovation in Yamasaki's design was the work of John Skilling and Leslie Robertson, the engineers who were in charge of the structure of the towers. Most skyscrapers up to the time of the World Trade Center were not supported by their outside walls, but by steel or concrete "skeletons," frames of columns and beams put together into a three-dimensional grid running all the way through the building. The invention of the steel skeleton made the first skyscrapers possible in the eighteen-eighties, since exterior walls alone could not bear the weight of a very tall building—they would have had to be dozens of feet thick at the bottom. But with steel, and later concrete, frames the weight could be carried on a light structure that was no bulkier at the bottom than at the top. By the middle of the twentieth century, the aesthetics of the modern skyscraper had developed to the point where the exterior walls were often made of nothing but glass—

"curtain walls" hung on the skeletal frame.

But the skeletal system is not without disadvantages. Since the frame fills the entire volume of the building, it requires a lot of structural material, and the interior space is frequently interrupted by columns. Robertson was an early proponent of an alternative structural system, known as the framed tube, a kind of web of metal that formed so tight a latticework on the exterior that it could support the weight of the building by itself. (It is something like a gigantic version of a wire-mesh litter basket, which is an exceptionally strong piece of street furniture.) The tube was the most advanced form of skyscraper construction in the nineteen-sixties, and before the World Trade Center it had been tried on a limited basis, including Yamasaki's own small IBM building in Seattle, finished in 1964. Building the World Trade Center as a tube represented a striking irony, since by having the exterior walls bear the weight of the building, it meant that the tallest skyscraper in the world would have a closer kinship in some ways to old-fashioned buildings with load-bearing walls than to other skyscrapers. But unlike traditional load-bearing walls of masonry, framed tubes were light, often requiring as little as half the material needed to support a conventionally framed skyscraper of the same size. In an age when the goal of technology often seemed to be to find a way to make everything lighter, from airplanes to cars to

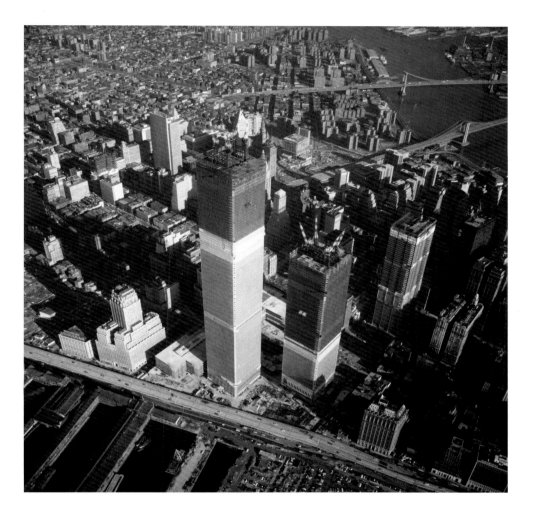

Aerial view of the World Trade Center when it was nearly completed,
before construction began on Battery Park City
and the World Financial Center.

household products, this seemed like a virtue.

When the buildings were hit by airplanes, of course, their lightness was less assuredly a positive element, though there is no certainty that another structural system would have performed differently under the tragic circumstances of September 11. Such catastrophic events were not imagined when the towers were designed; indeed, until very recently structural engineers have considered wind to pose the greatest threat to skyscrapers. Other than keeping tall buildings standing, bracing them against the wind has usually been the primary goal. The dense latticework of the tube provided good wind bracing, especially in concert with the floor slabs, huge squares that were anchored to the tube and served to provide horizontal stability

from top to bottom. The weakest part of the design, in a sense, was the core of the building, the central area containing the stairs and the elevators, since it was not a part of the main structural support, and it was made largely of gypsum, or plasterboard, which provided no resistance at all to the force of the airplanes that hit the towers when they were attacked.

But when the towers were being designed, Yamasaki and the Port Authority were thinking mainly of things like what kind of office space they would contain, and from this standpoint the tube system was only to the good, since it allowed the World Trade Center's enormous floors to be largely open and free of columns, exactly what tenants liked. The structural system pleased Yamasaki for another reason: He was nervous about heights and uncomfortable in buildings with wide expanses of glass on the upper floors. The tight mesh of the tube structure meant that the offices in the trade center would have to have narrow windows. Yamasaki, believing that there was psychological comfort in windows that were narrower than his own shoulder span, ended up reducing the width of the windows to twenty-two inches, beyond even what the engineers required. The result was that windows took up only thirty percent of the façade of the trade center towers, as compared to fifty, sixty, or seventy percent of the façade of many other modern skyscrapers. So slender

were the windows that from a short distance away, Yamasaki's towers would seem almost to be made of solid metal.

When they were completed in the early nineteen-seventies, the towers were an architectural misfit: The tallest buildings in the world and among the largest, their architecture was delicate, almost dainty. Yamasaki had put neo-Gothic arches at the bases of the towers and at the top, which he thought would give the buildings a humane air but served only to make them seem fussy. The buildings represented an extraordinary technological leap in skyscraper design, but their aesthetic seemed to deny the engineering innovations that the towers represented, and when the World Trade Center opened, it was thought of more as backward-looking than as avant-garde. From the standpoint of urban planning the buildings were utterly rear guard, since everything about Yamasaki's design, from the simple, boxy shape of the towers to the enormous paved plaza at the center of the complex, had already gone out of fashion by the nineteen-seventies. When the trade center was built, the streets that ran through its thirteen-acre site were obliterated in favor of a huge "superblock," essentially a podium on which the structures were set. Retail space was originally not in storefronts but underground so as not to disturb the prim perfection Yamasaki

aspired to. The overall design was more of an abstract composition than a functioning piece of the city; indeed, like so much urban renewal from the nineteen-fifties and sixties, the very basis of the design was a rejection of the traditional form of the city.

It may seem odd, given that these were the world's largest skyscrapers, to say that their design was anti-urban, but in a way that is precisely what it was. The layout of the trade center embodied a planning theory that viewed the complex, disorderly form of the city mainly as a nuisance, as a mess to be cleaned up and replaced with gleaming new abstract objects. It is not surprising that the Port Authority paid little heed to the protests of the merchants whose shops made up one of Manhattan's more vibrant small commercial districts, the blocks of electronics stores known as "Radio Row," which lay in the path of the proposed trade center. It was inconceivable to the Port Authority that there could be anything worth saving in this messy mix of old buildings. Sweeping away the old, and providing a clean slate for the new, was the highest and best calling of city planning, or so the Port Authority seemed to believe.

The conviction that bigger and bigger doses of American power and know-how could solve any problem had plenty of other manifestations in American culture in those years, many with more serious consequences than the destruction of older neighborhoods

for gigantic buildings that did not seem to belong there. But as this view was beginning to be questioned in the political sphere, it was coming increasingly to be challenged in the realm of planning and design as well. By the time the trade center was underway, it seemed out of date as a piece of urban planning, where the freshest thinking, inspired by such writers as Jane Jacobs, was moving toward a greater respect for the complex and subtle fabric of real streets, older neighborhoods and smaller scale. The gigantism that was beloved by the Port Authority was rapidly losing its appeal, and in New York, the Landmarks Preservation Commission was firmly establishing itself as a force moving the urban culture in a different direction.

The consequence of this is that by the time the trade center was finished in the early seventies, it seemed to flaunt a view that had become determinedly reactionary. It was not surprising that a few years later when Battery Park City, a complex of housing and commercial buildings was erected on landfill in the Hudson River adjacent to the trade center (landfill that came mainly from the trade center's excavation), its planners made much of the fact that it would have "traditional" streets and blockfronts like the rest of New York, as if in deliberate rebuke to Yamasaki's plan.

Back when the trade center was still in the planning stages, several New York real-estate developers, claiming to share the views

of preservationists, formed the Committee for a Reasonable World Trade Center to push for a smaller project that would not destroy Radio Row or rise so high in the skyline. In fact, their real concern was less with the small merchants of Radio Row than with the competition that ten million square feet of office space would pose for their buildings. They got nowhere against the political forces lined up in favor of the trade center, but they needn't have worried. There wasn't much of a market for all that space, and before the buildings were finished the Port Authority announced that it would fill the bulk of one tower with its own offices, and the State of New York said it would take most of another. The public agencies never admitted it in so many words, but they moved in themselves because there weren't enough commercial tenants who wanted to be in Lower Manhattan to fill the towers up.

Great height was itself beginning to go out of fashion when the trade center opened, at least in the United States. The World Trade Center towers were the tallest buildings in the world for only a short time after their completion—the Sears Tower in Chicago, only slightly higher, took the title in 1974. Not a lot of extremely tall skyscrapers went up in the late seventies and early eighties as the economy struggled, and when it returned, most American developers had lost interest in the notion of going still taller. They understood that super-tall buildings, even with structural innovations like the ones at the trade center, are rarely the most profitable kinds of buildings to build. Their value is as signboards, as advertisements and symbols more than as conventional real estate. And so it was not surprising that when the Sears Tower was surpassed as the world's tallest building in 1996, it was not by another American structure but by the corncoblike Petronas Towers in Malaysia, which rose to 1,476 feet. Asian countries, newly strutting their presence on the world economic stage, took over the quest to build ever-taller towers. After Petronas, buildings were designed for Shanghai that went still higher.

The shift in sensibility that made the trade center out of date as a piece of urban planning when it opened had an even more powerful effect on the perception of the buildings as architecture. By the nineteen-seventies, boxy steel-and-glass skyscrapers no longer seemed like fresh and exciting presences on the cityscape. There were too many boxes, and they were too much the same, so much so that many people dismissed the best examples of modernism, like the Seagram Building, along with the worst, like the buildings that filled Third Avenue. When the World Trade Center was finished, the only skyscrapers New Yorkers seemed to like were the old ones, buildings like the Woolworth and the Chrysler and Rockefeller Center: We delighted in their shapes, and their decoration, and the way

they seemed full of emotion. Most of all, I think, we took joy in the way in which these older buildings had fanciful crowns, and were sculptural presences on the skyline. Next to these buildings Yamasaki's flat-topped towers seemed, if not mean-spirited, at least lacking in imagination. In a book about Manhattan, I called them "boring, so utterly banal as to be unworthy of the head-quarters of a bank in Omaha," and I meant it. The towers seemed an occasion to mourn not just for the skyline, which they trans-formed so utterly, pushing the center of gravity downtown but also throwing its bal-ance off kilter; in their very flatness and blunt-ness the towers seemed to dare us to react to buildings with emotion, and to taunt us for thinking of skyscrapers as objects of affec-tion. They seemed designed by people who did not understand that architecture could inspire love.

What happened? There are many phases to the relationships we have with buildings, and almost invariably they come around to acceptance. Long before September 11, the World Trade Center had begun to seem more palatable, and there are several reasons why. The first is common to all architecture: It is there, and you cannot avoid it the way you can choose not to listen to a piece of music you dislike, or not to attend a play that you expect will make you uncomfortable. Buildings are present in a way that no other form of art is, and that requires us to adapt ourselves to them. We can walk on another block to keep some buildings out of our field of vision, but that technique was of little help with the World Trade Center, since it was visible from almost everywhere. You saw it not just in Lower Manhattan but at the end of a vista down avenues from Midtown; you saw it from the train tracks and the highways in New Jersey; you saw it from the river and you saw it from Brooklyn and you saw it all the time from the air. It became, for many people, an orienting device, the campanile of the huge city, and thus its enormity served, curiously, to make New York feel smaller, for when you saw the trade center towers and because of them you knew where you were, then the city was more manageable. It is one of the paradoxes of the trade center that its vast-ness could in this way confer intimacy, but so it was, and that made acceptance easier, less grudging.

Popular culture began to embrace the towers, long before high culture did. While Dino de Laurentiis never achieved much success in his attempt to remake *King Kong* at the trade center, despite the striking image of King Kong straddling the two towers, Superman seemed entirely at home flying beside them, and the towers began to appear almost everywhere an iconic view of the skyline was called for—covers of *The New*

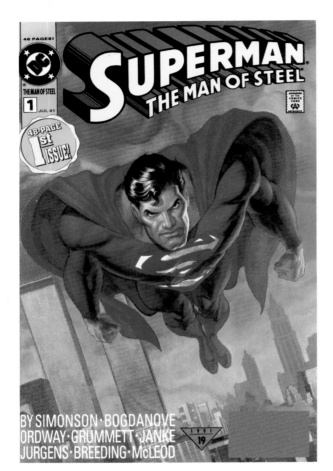

Superman, *July 1991.*

Yorker, television commercials, travel posters, and little souvenir buildings. (Miniature trade centers never outsold little Empire State Buildings, however, perhaps because they looked too much like tiny boxes.) There was a whole different level of acceptance for people who used the World Trade Center towers, and as the years passed, the nature of the uses within the buildings changed. In 1976 Windows on the World, the extraordinary, splashy, sprawling restaurant on top of the north tower, opened to a great fanfare, and it brought a sense of indulgence to

buildings that, for all their size, seemed until then to have a kind of puritanical restraint. Then Philippe Petit, the aerialist who walked between the towers, and George Willig, the climber who crawled up one of them, made the architecture the setting for performance art, and added a level of glee that Yamasaki surely never dreamed of. Petit and Willig enlisted the towers as co-performers, and humanized them. Things were not the same after Petit and Willig. They were better; their escapades made the towers relax.

The construction of Battery Park City and its centerpiece, the World Financial Center, helped, too. Cesar Pelli, the architect of the financial center, said that he thought of the four squat towers as foothills to the mountains that were the trade center's towers, and he did what had seemed impossible, which was bring Yamasaki's huge buildings into some kind of urban context, at least from the riverfront and the west. When Battery Park City and the World Financial Center were constructed, the trade center towers no longer stood aloof; these buildings that had tried to stand apart were embraced by neighbors that brought them visually into a larger composition.

All of these events—the performances of Petit, the architecture of Pelli—coincided with the beginnings of an upturn in the city's economy, and with it came a gradual shift in the tenancy of the towers toward the financial companies and trading organizations

for which they were originally intended. Eventually the state offices and many of the Port Authority offices moved elsewhere to make room for higher-paying tenants, the restaurants and shops in the underground mall went through several cycles of tenancy, and the place began to take on the qualities of a medium-size city that was neither newly ascendant nor in decline, but entering a kind of self-satisfied middle age. Its complacency was shattered in 1993 with the first terrorist attack, in the form of a bomb set off in a truck in the underground parking garage, which resulted in significant prop-erty damage but miraculously little human cost, and seemed to many people less like a warning of worse things to come than a wel-come opportunity to spruce up what was, by then, a good two decades old.

The trade center had begun to seem more benign from the outside as well as from within in the years before the 1993 bombing, and it is hard to tell, looking back, how much of this is a matter of becoming con-tinually more accustomed to its presence, and how much it is a matter of changing attitudes toward architecture in general. As the trade center's image as a work of archi-tecture suffered at the beginning from being out of cycle with architectural fashion, it appeared in a different light a decade or so later, as the architecture world became less willing to be seduced by the idea of faux Art Deco, faux Gothic, and faux classical towers, and began to look with new respect toward modernism. Crisp metal boxes did not seem so harsh, and sometimes they even seemed refreshing. The particulars of Yamasaki's design—the plainness, the bluntness, of the buildings—began to seem like a virtue. And the façades did, after all, emphasize the vertical, as if Yamasaki had heard Louis Sullivan's famous exhortation—"the sky-scraper must be tall, every inch of it tall....every inch a proud and soaring thing, rising in sheer exaltation that from bottom to top it is a unit without a single dissenting line"—and tried to interpret it

The New Yorker, *January 10, 2000.*
Illustration by Mark Ulriksen.

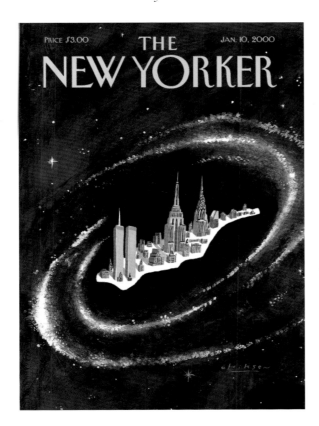

as best he could. That the surfaces were mostly of metal and not of glass may have made the towers less than exhilarating to be in—it had to have been frustrating to have an office seventy or eighty or ninety stories above the greatest urban view in the world and never see a panorama of it—but Yamasaki's metallic façades made the buildings seem far less brittle than glass. The towers did wonderful things in the light. They didn't glare, like glass, but they didn't absorb all the light either, the way stone or brick buildings often do. They reflected it back, softly, with a gentleness that belied their size.

It is the sense of these buildings in the light, the extraordinary way they could sometimes appear almost to glow, that Sonja Bullaty and Angelo Lomeo capture so brilliantly. Their images of the towers at dusk, at dawn, at night, at noon — every one of these pictures seems connected to a particular moment of the day—remind us how the towers, as much as any buildings that have ever been, existed in the light, and changed as the light changed. While Bullaty and Lomeo journeyed tirelessly around the city to show us the towers in every possible way from every possible angle, it is not their movement but the movement of the sun that we remember most, because it is the view of these buildings in the light that raises them to something exalted. By tying the towers always to the light, Bullaty and Lomeo give warmth, even

majesty, to the buildings, and to the city of which they were a part, and confer upon them a precious serenity.

These images help you view the towers as benign objects, which is how, now, we must see them. Yamasaki was motivated mainly by a desire to get away from what he thought was the harshness of modern architecture, but he ended up designing one of the greatest pieces of modern sculpture of all time. The more you look at the towers the more they look like minimalist sculpture, and now there is no question that, in this way at least, Yamasaki was right: two of them was exactly the right number. One would have been deadly dull and three would have been a cluster. Two identical towers, set a hundred and thirty feet apart, corner to corner, could play off against each other, their masses not as inert as they looked, since each shape was engaged with the other. Your eye went back and forth, always seeing each tower in relationship to its twin, and you could feel now, more than ever before, how the surface made the towers seem solid enough to function as minimalist sculpture, yet soft enough to be decent to the eye.

The buildings came, over time, to have the appeal of quietness. It is the last thing you expected of them, as it is the last thing you would expect of any enormous towers, but it was how they were. The buildings that once seemed to be the most arrogant intrusions into the cityscape became background architecture

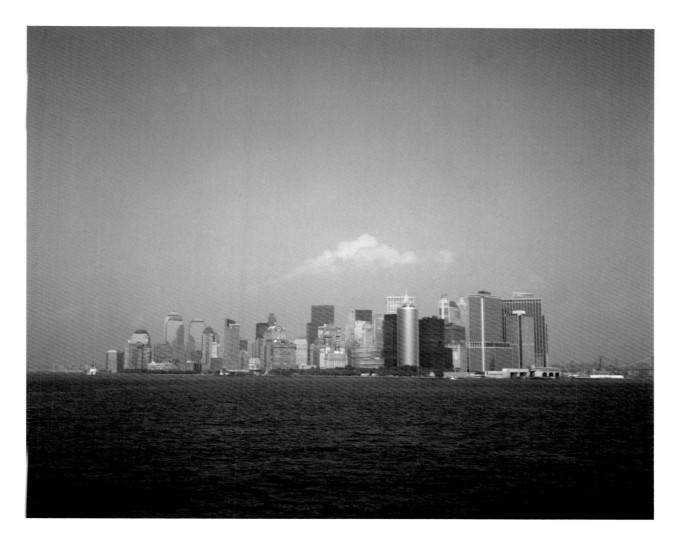

The Lower Manhattan skyline after September 11.

in spite of themselves. We accepted them, and over time they seemed to acquire a kind of grace. Now they are the first skyscraper martyrs, the first buildings whose photograph is sold by sidewalk vendors who might once have trafficked in pictures of John F. Kennedy and Martin Luther King. Without the towers the skyline has lost its weight, its meaning, and it appears to have melted away. Modernity always implied great change, but no one wanted to believe that this could mean cataclysm, or ever expected that the buildings that for so long had seemed to transcend emotion would come to inspire in us the deepest, most heartfelt longing.

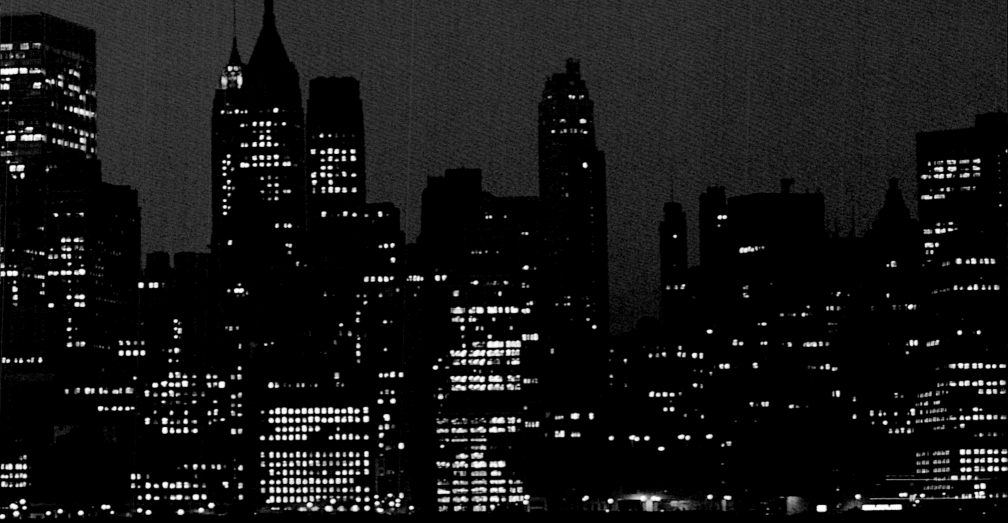

THE VIEW
LOOKING EAST
─────

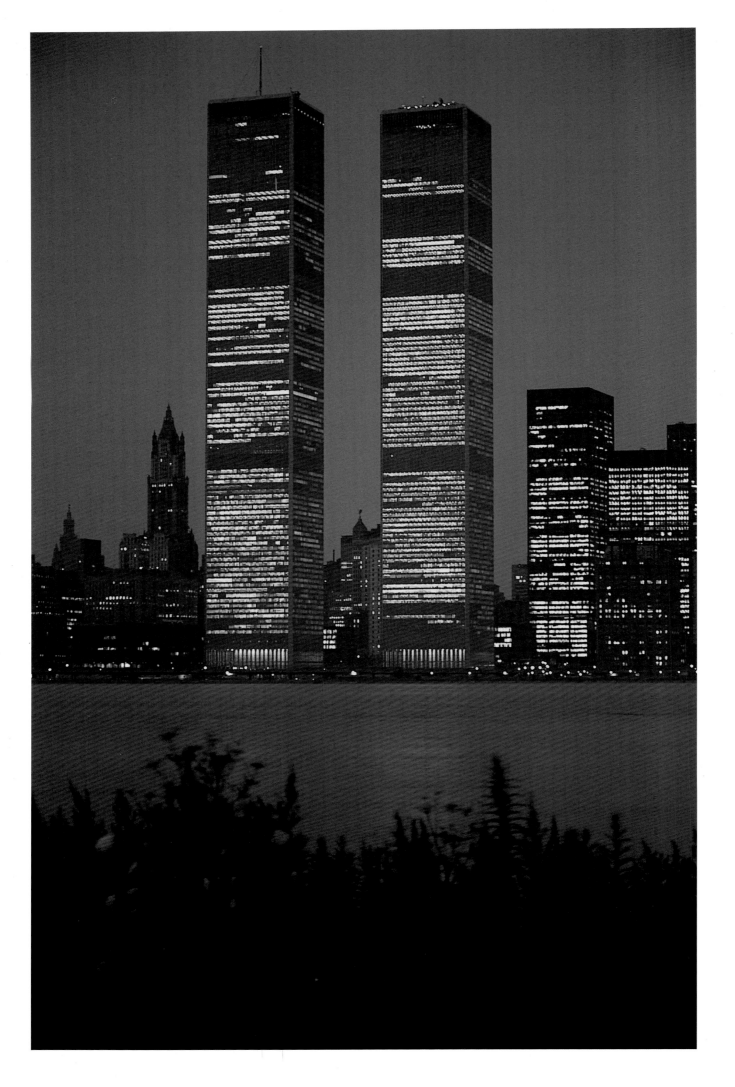

THE VIEW
LOOKING EAST

30

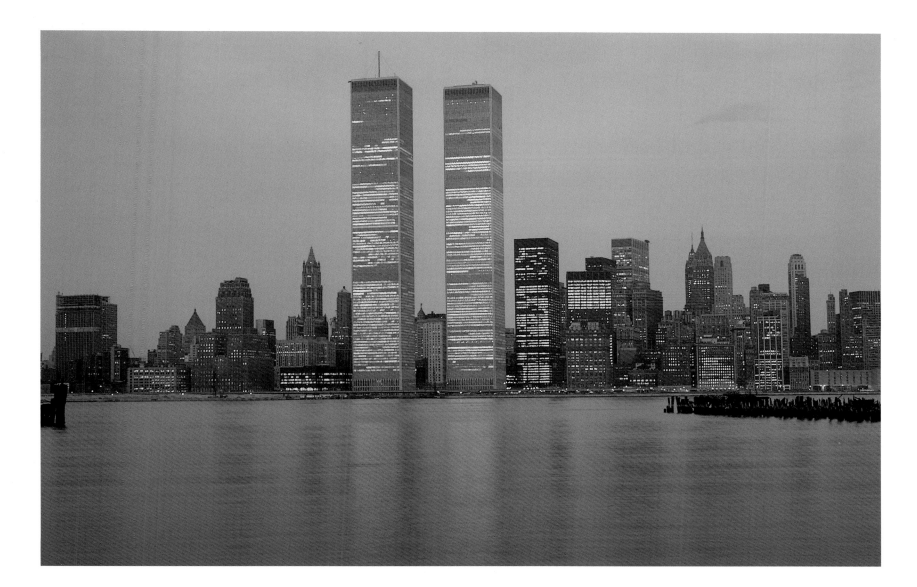

THE VIEW
LOOKING EAST

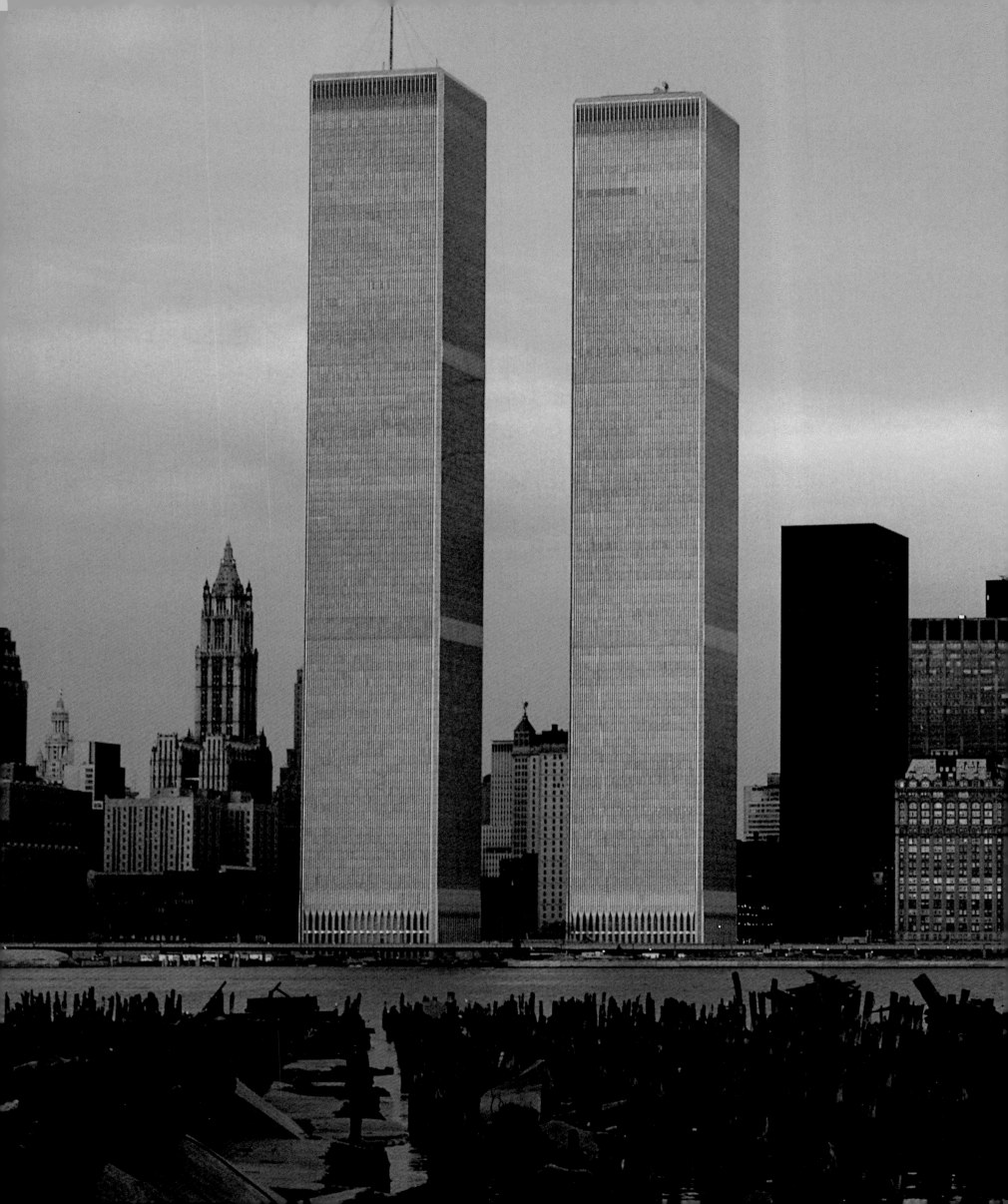

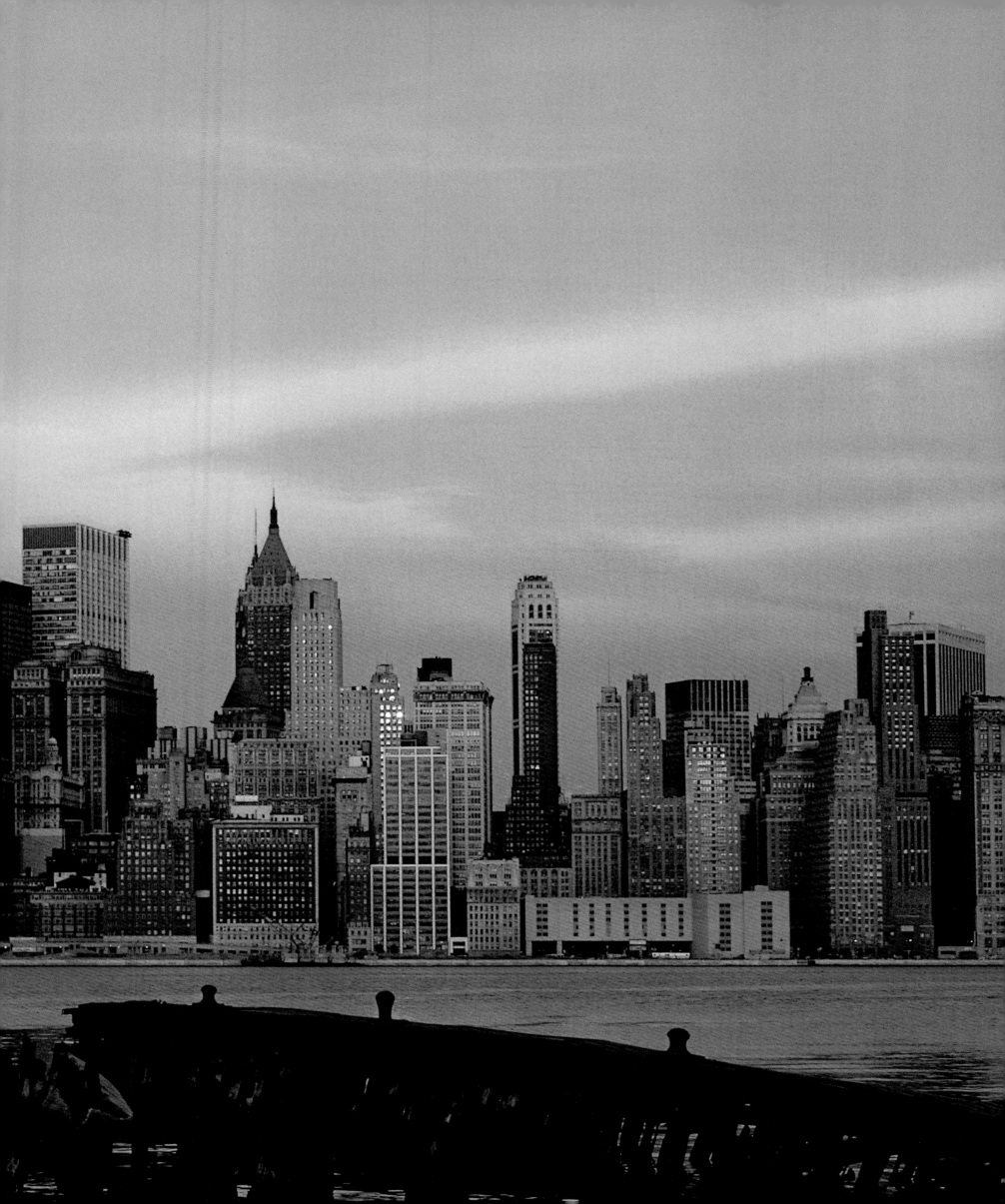

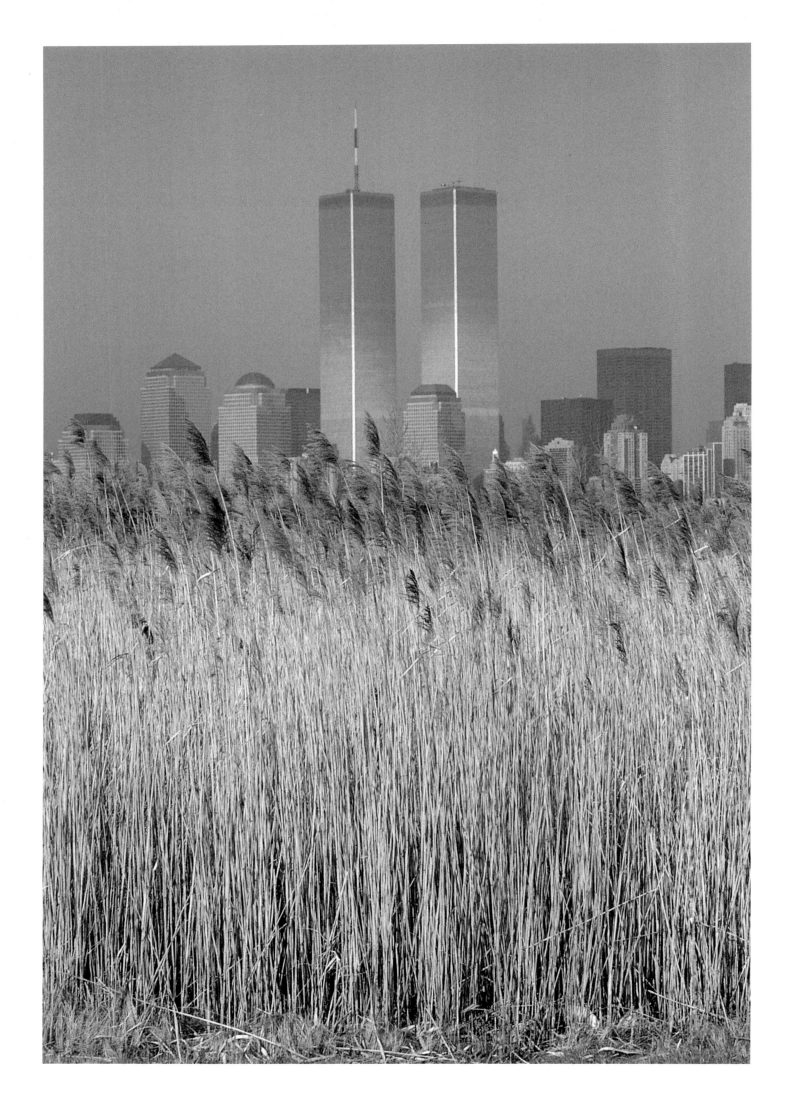

THE VIEW
LOOKING EAST

34

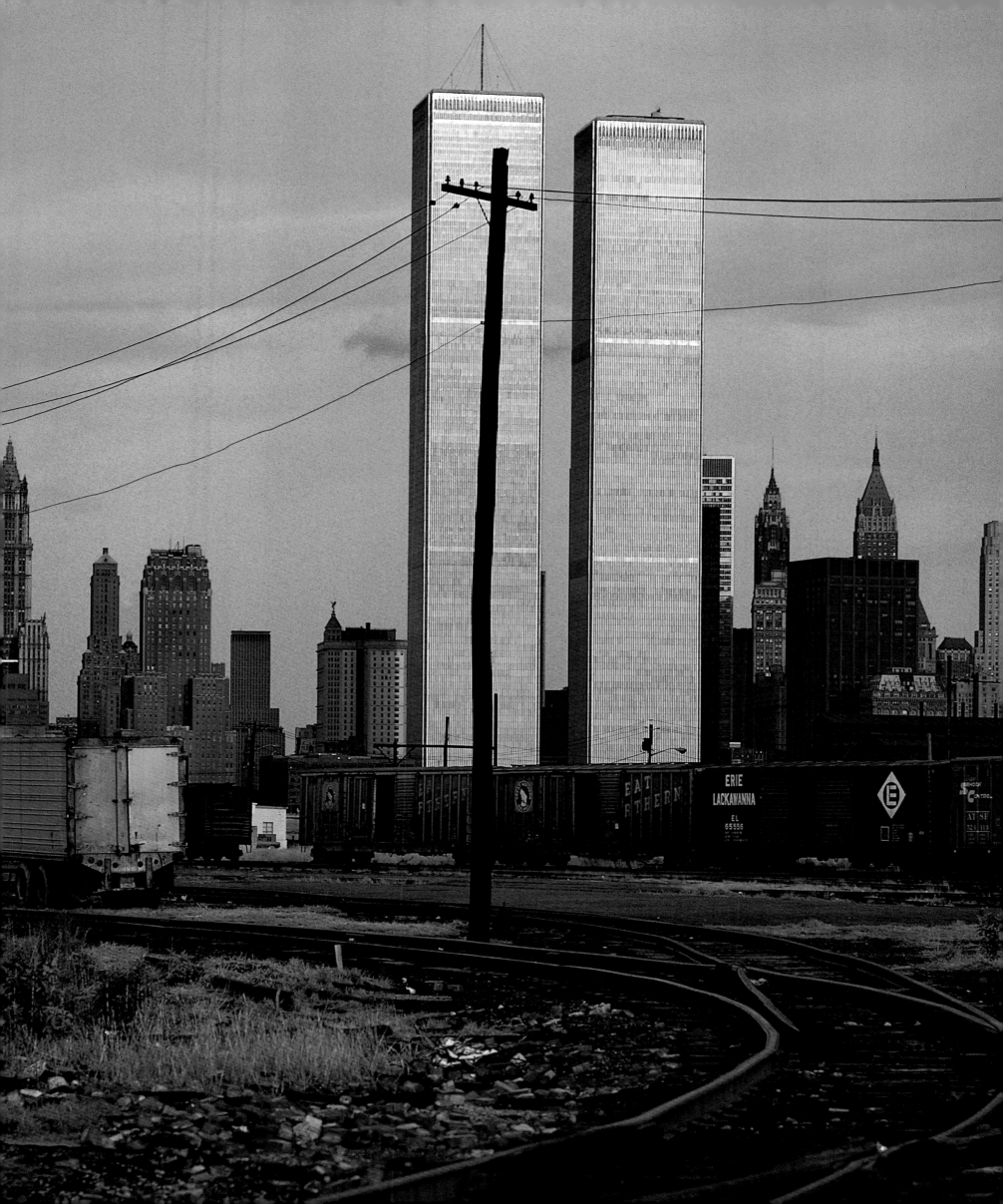

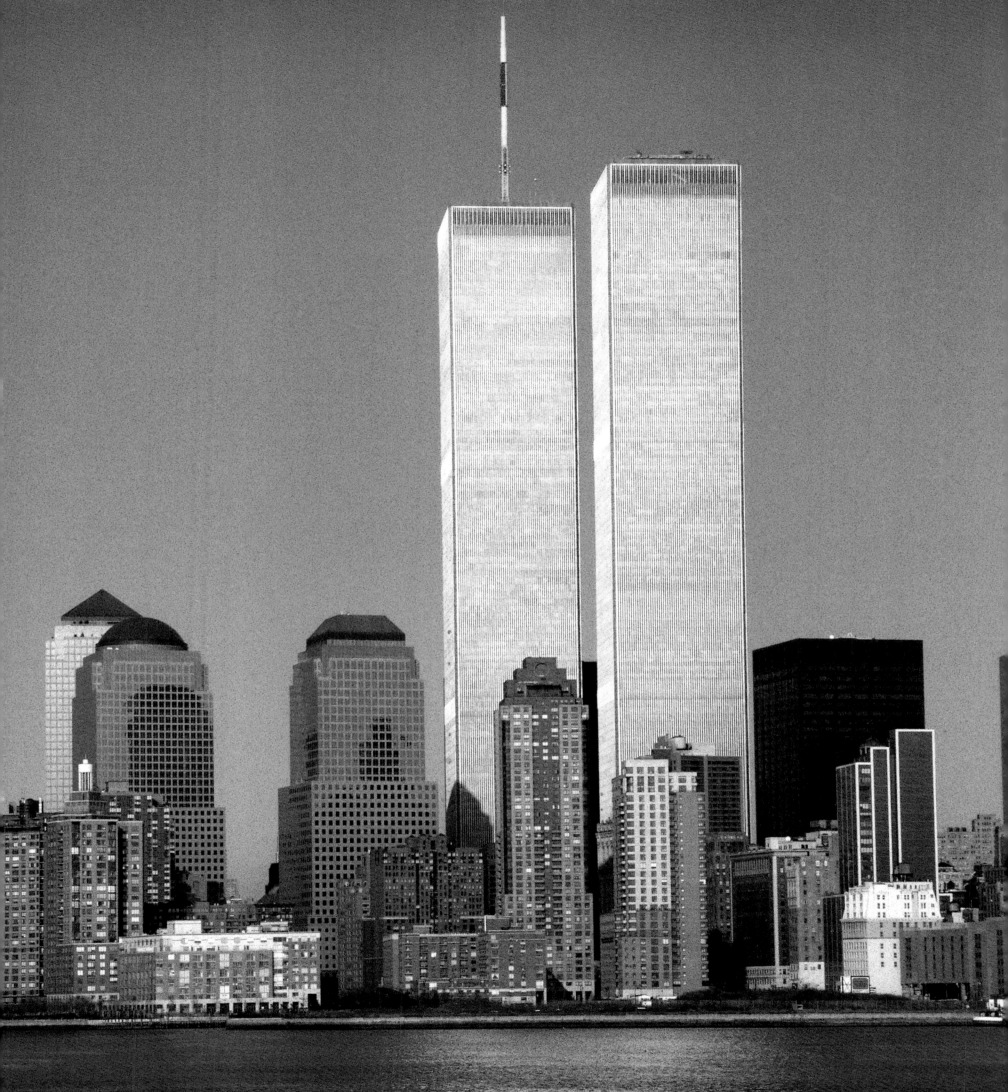

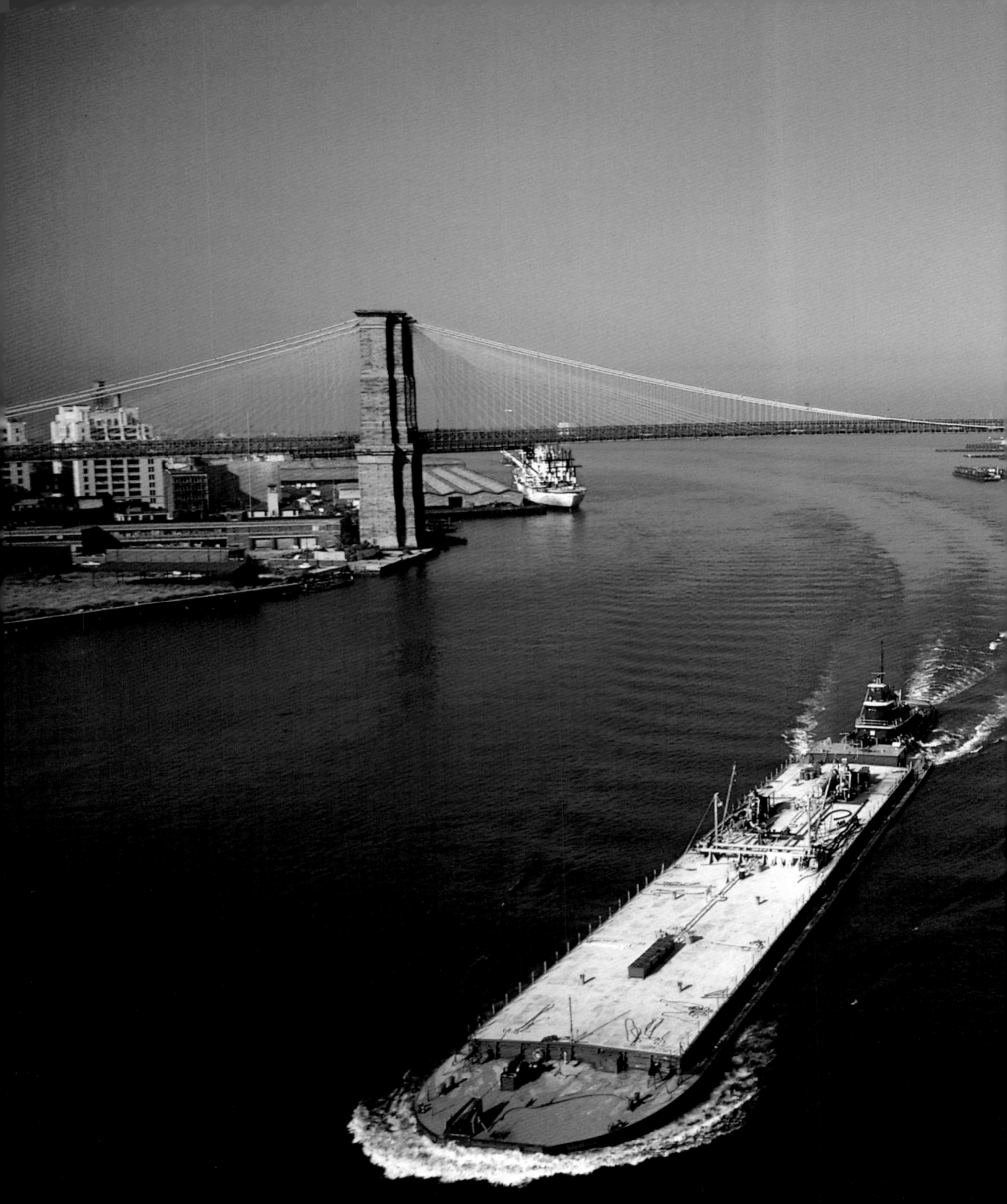

THE VIEW
LOOKING SOUTH

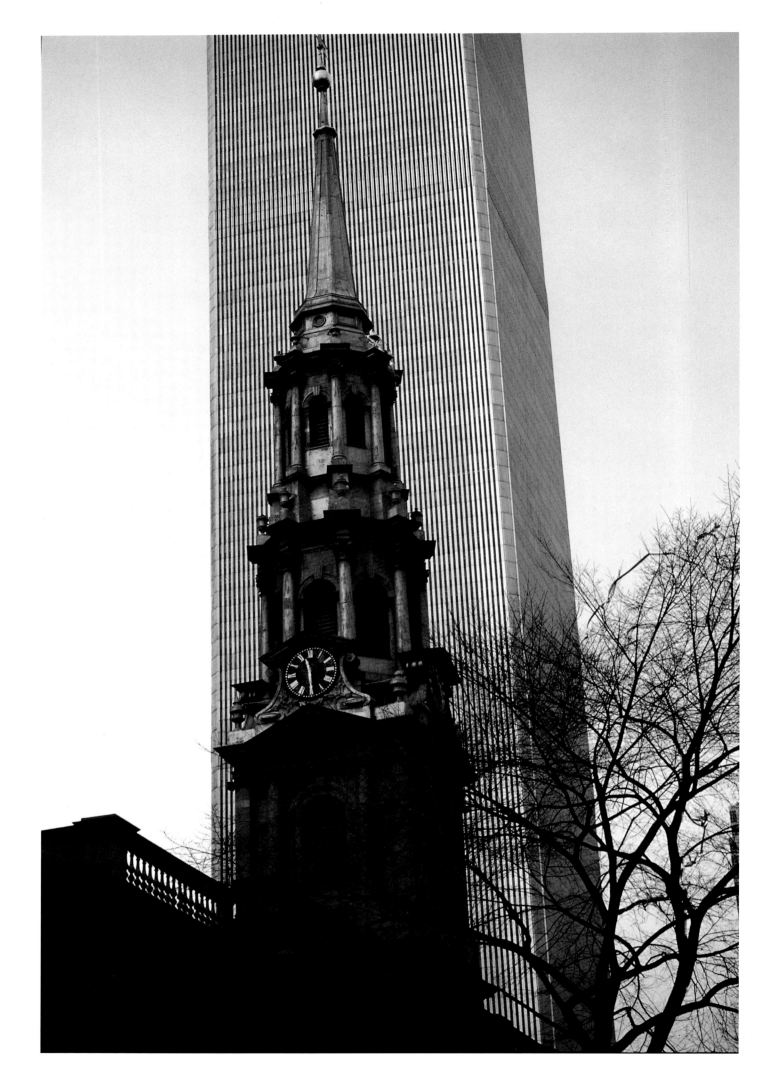

THE VIEW
LOOKING SOUTH

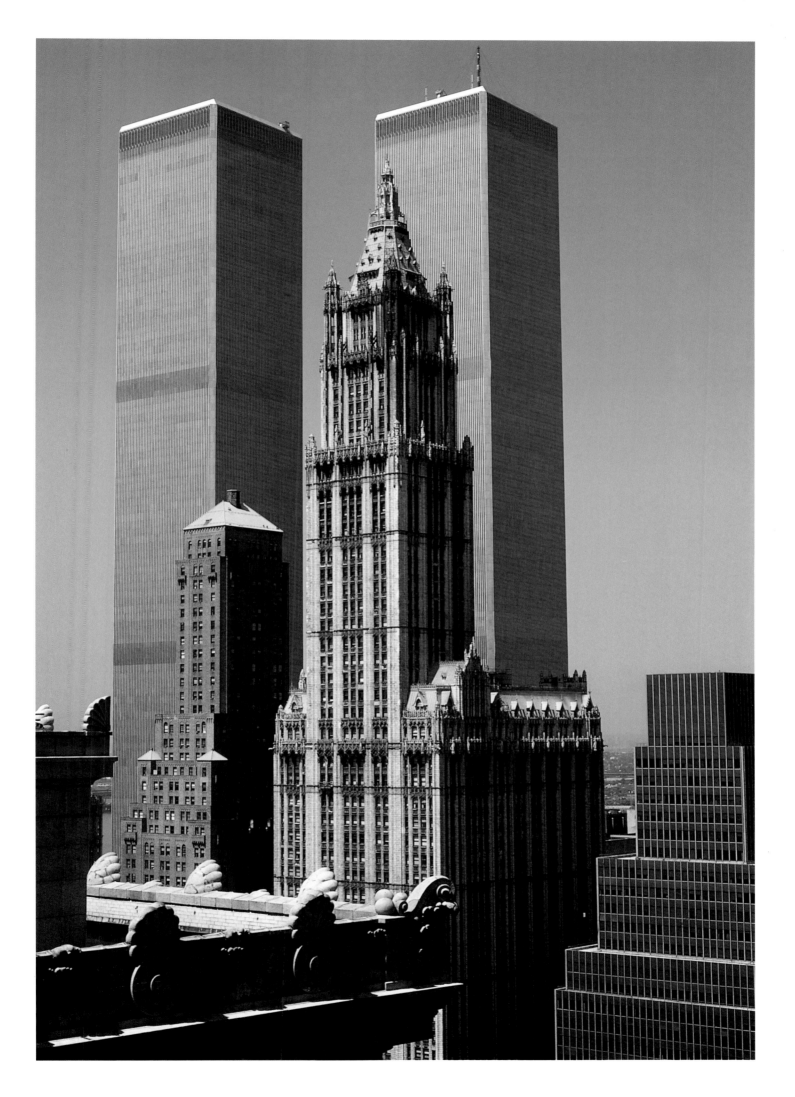

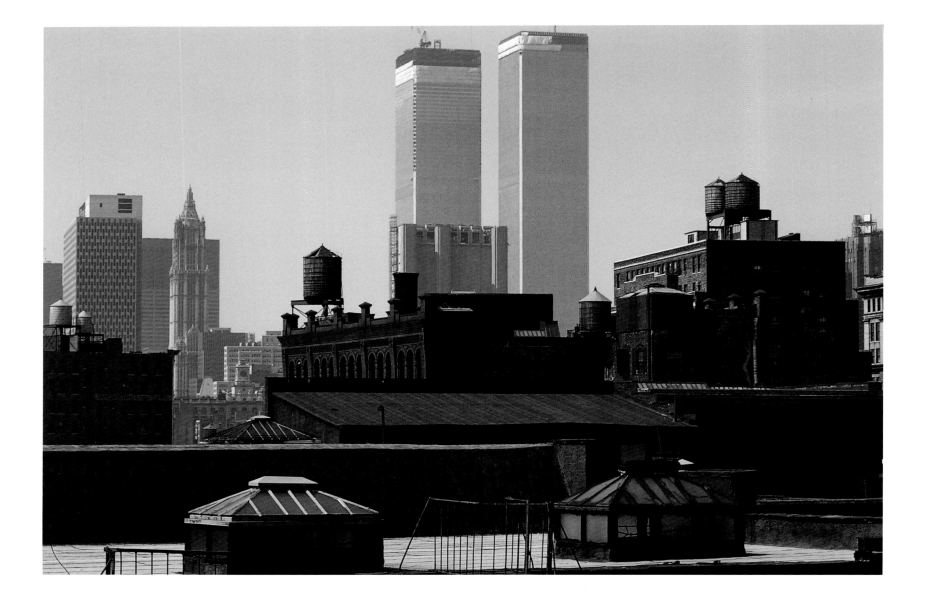

THE VIEW
LOOKING SOUTH

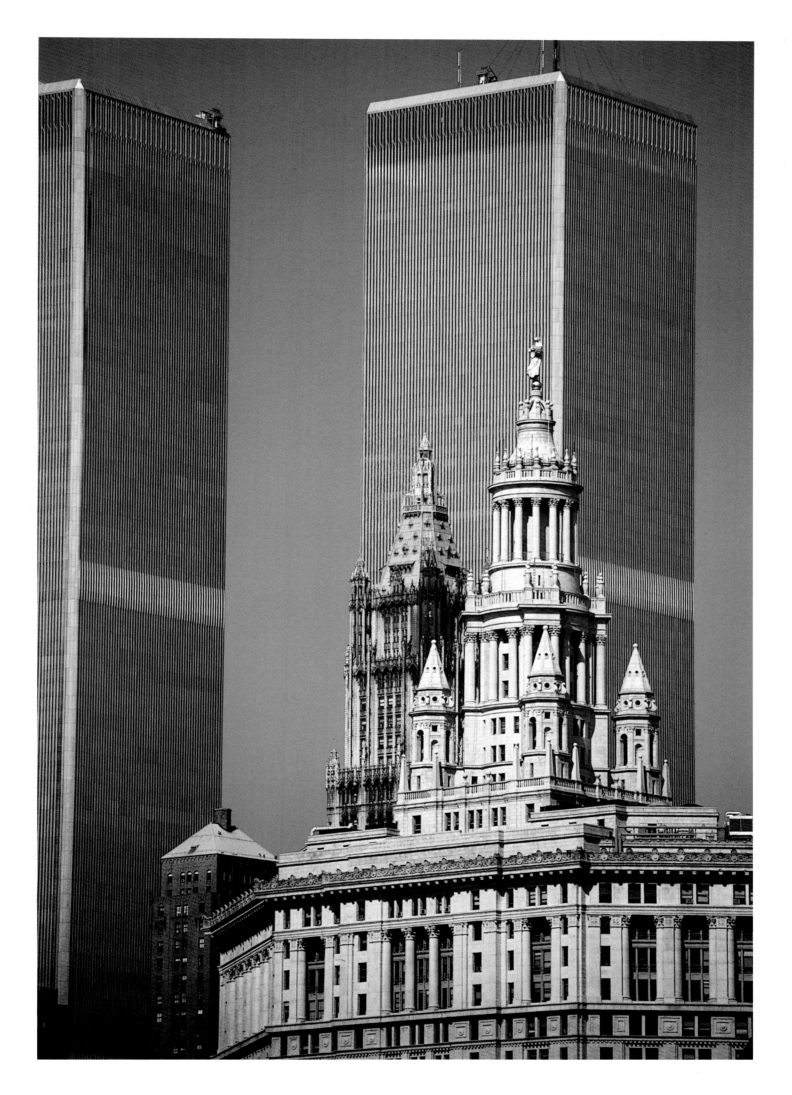

THE VIEW
LOOKING SOUTH

43

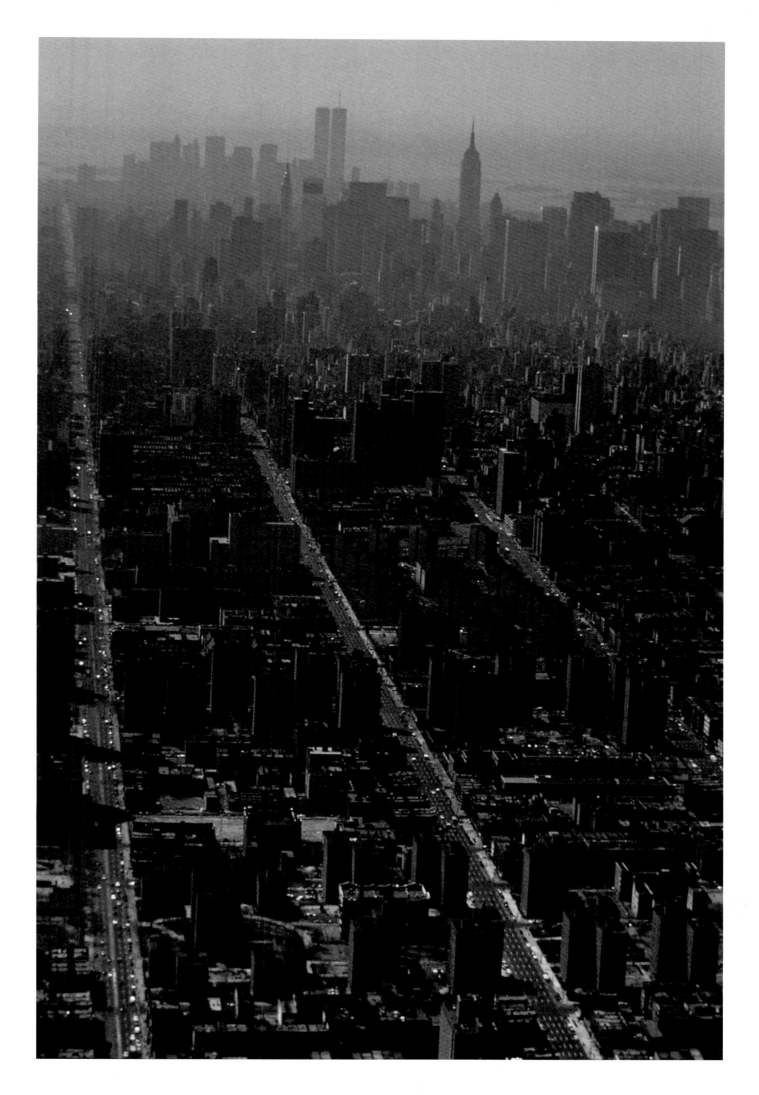

THE VIEW
LOOKING SOUTH

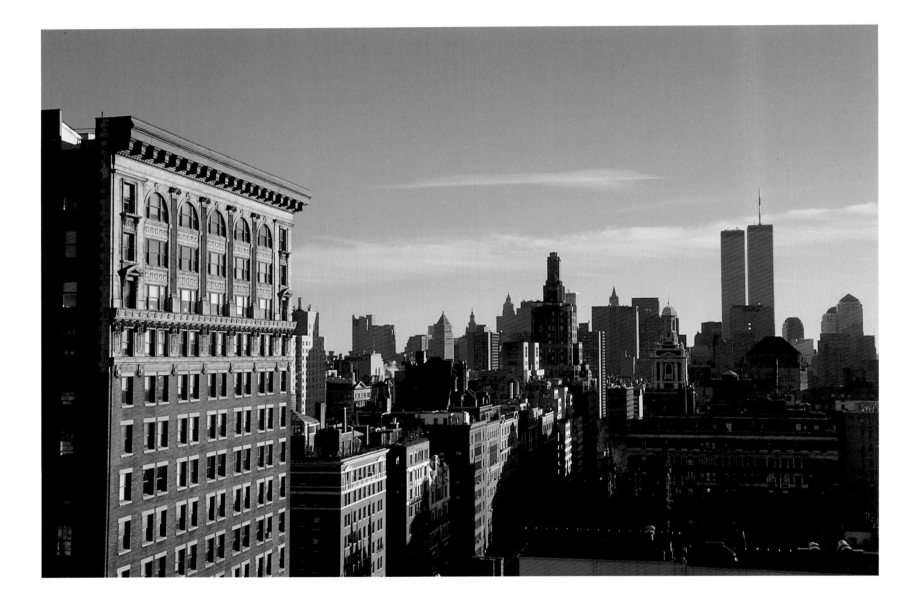

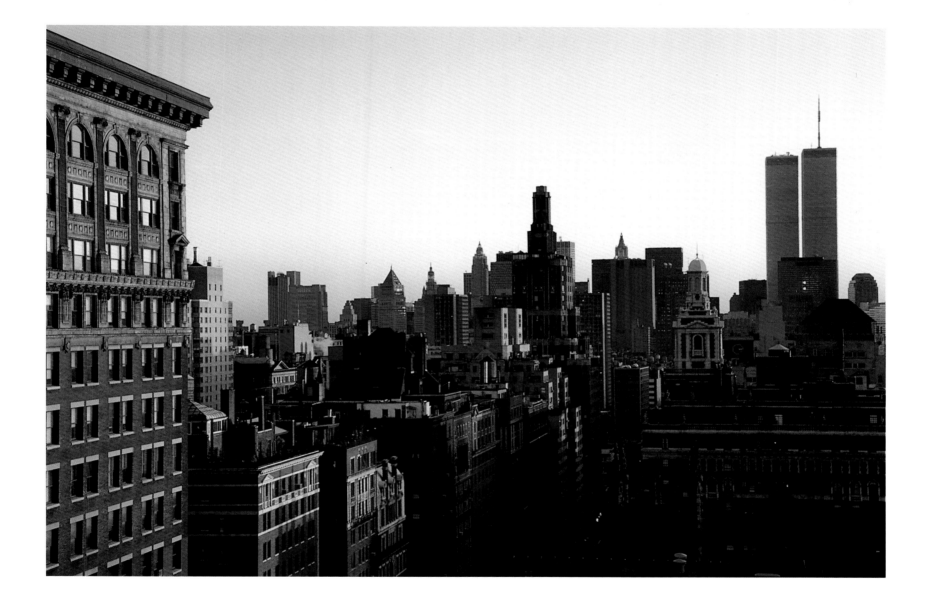

THE VIEW
LOOKING SOUTH

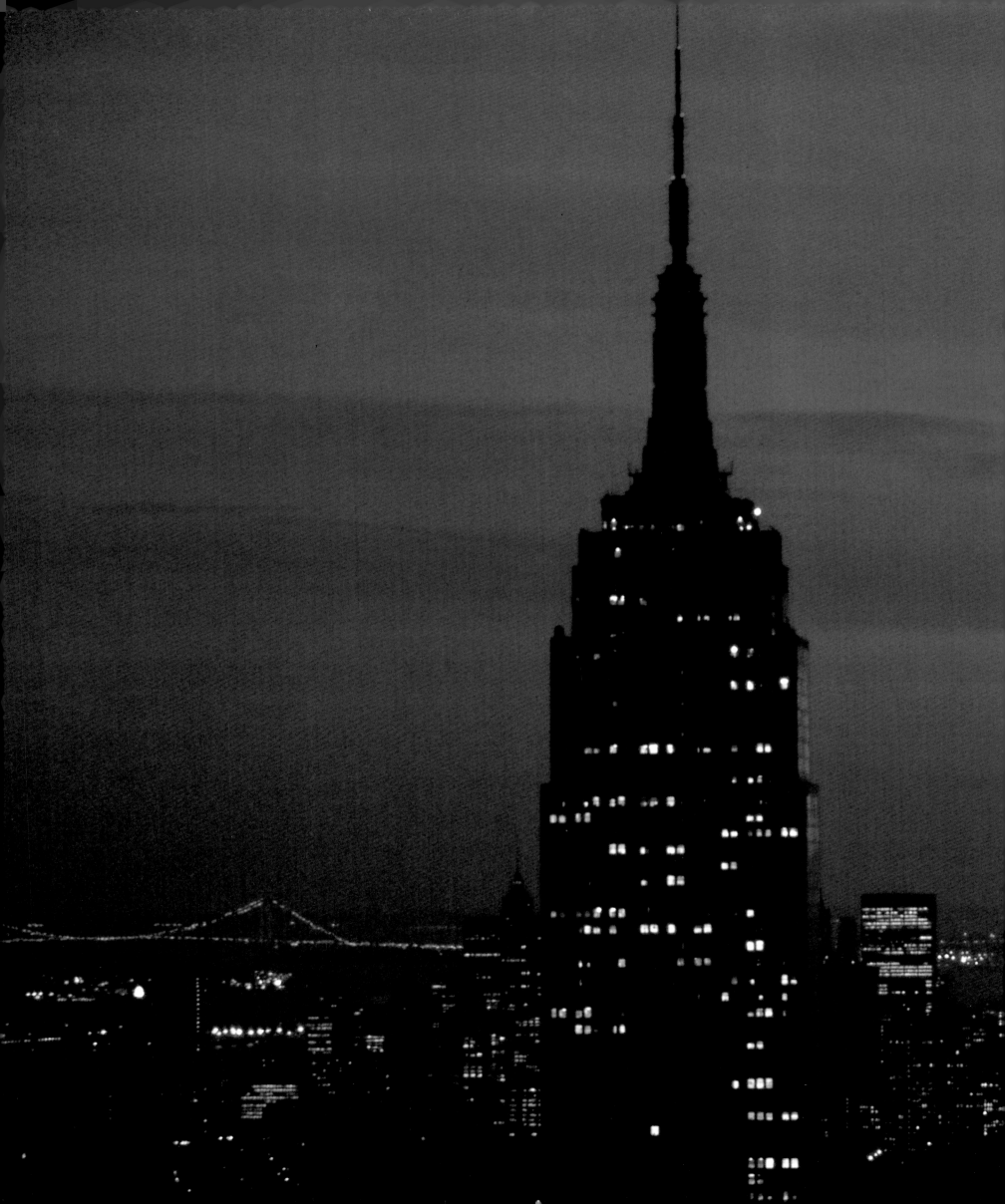

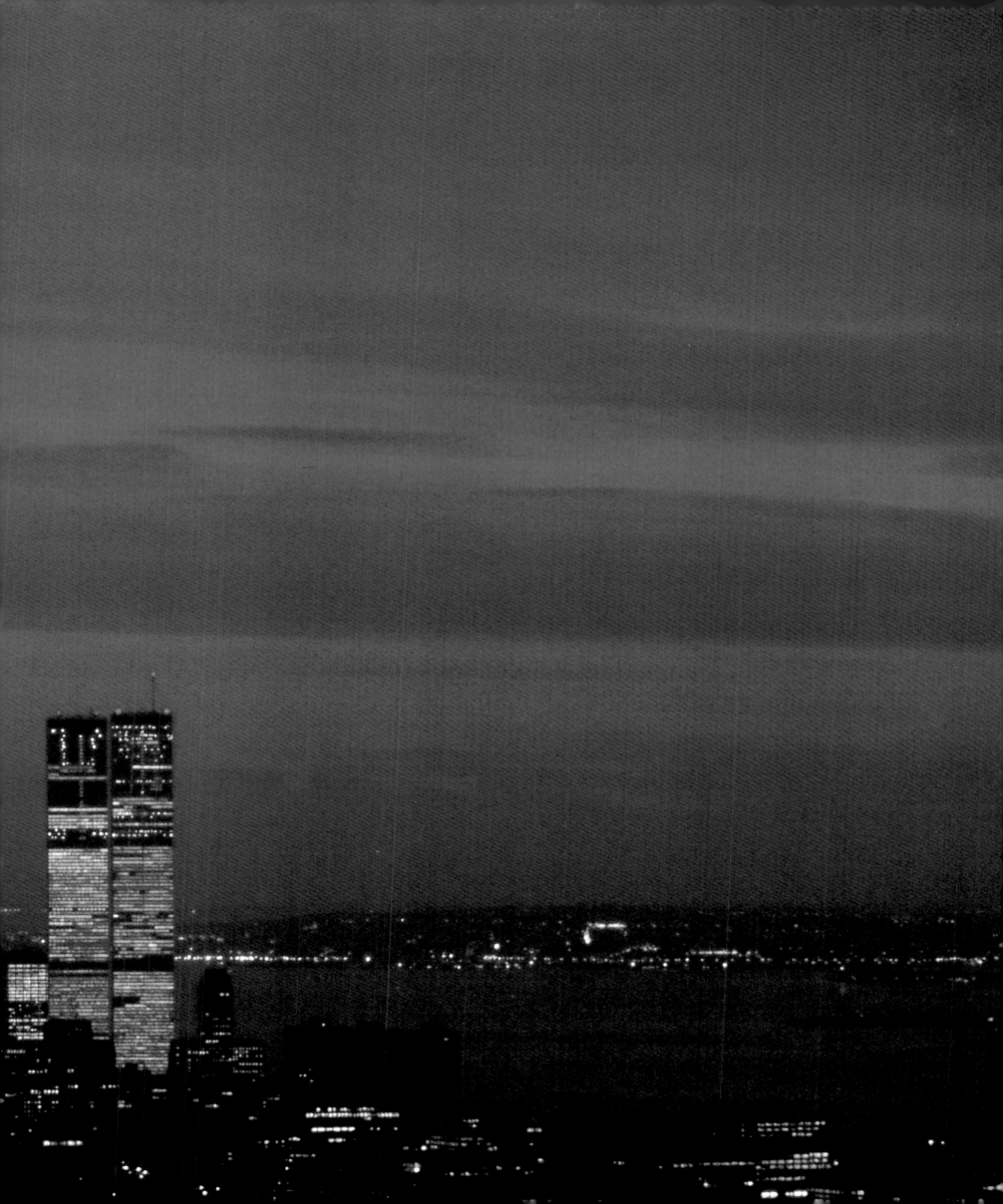

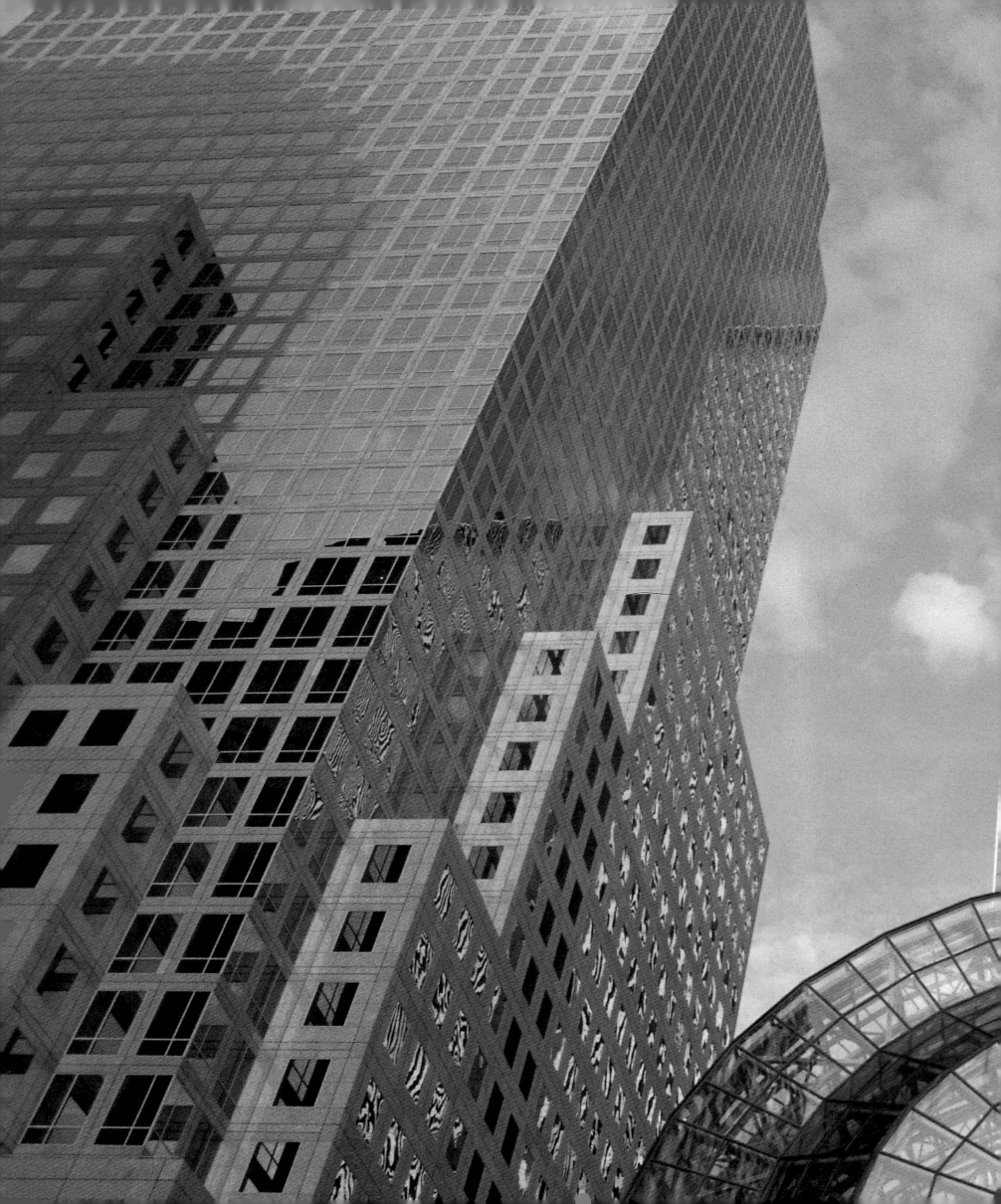

THE PLAZA

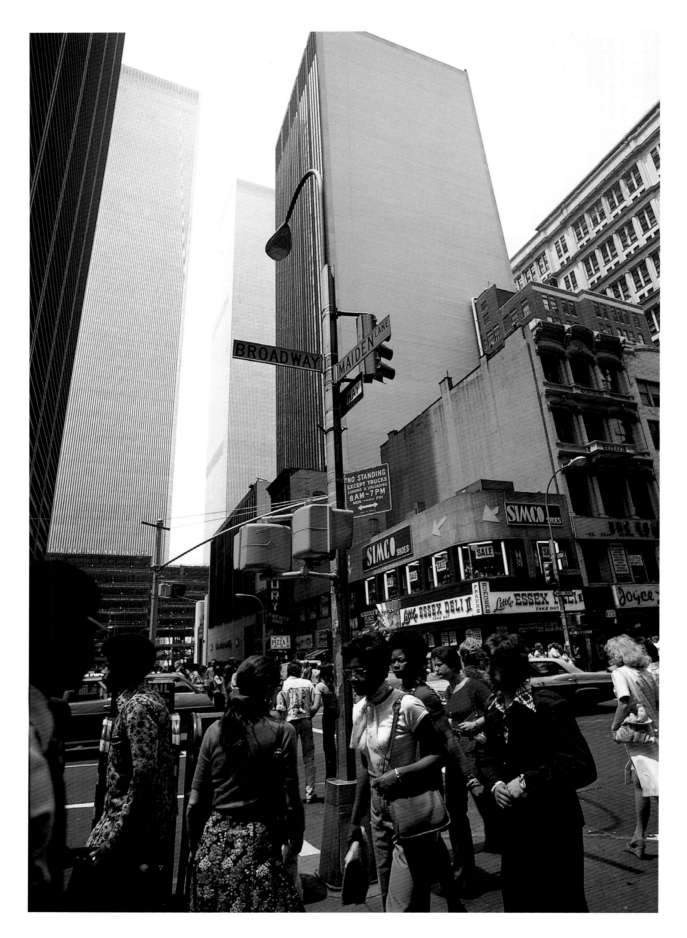

VIEW FROM THE WEST WINDOWS OF THE PUBLISHER'S OFFICE,
FACING THE WORLD TRADE CENTER TOWERS (RIGHT)
AND OF A FORMER STREET SCENE NEARBY (ABOVE).

THE PLAZA

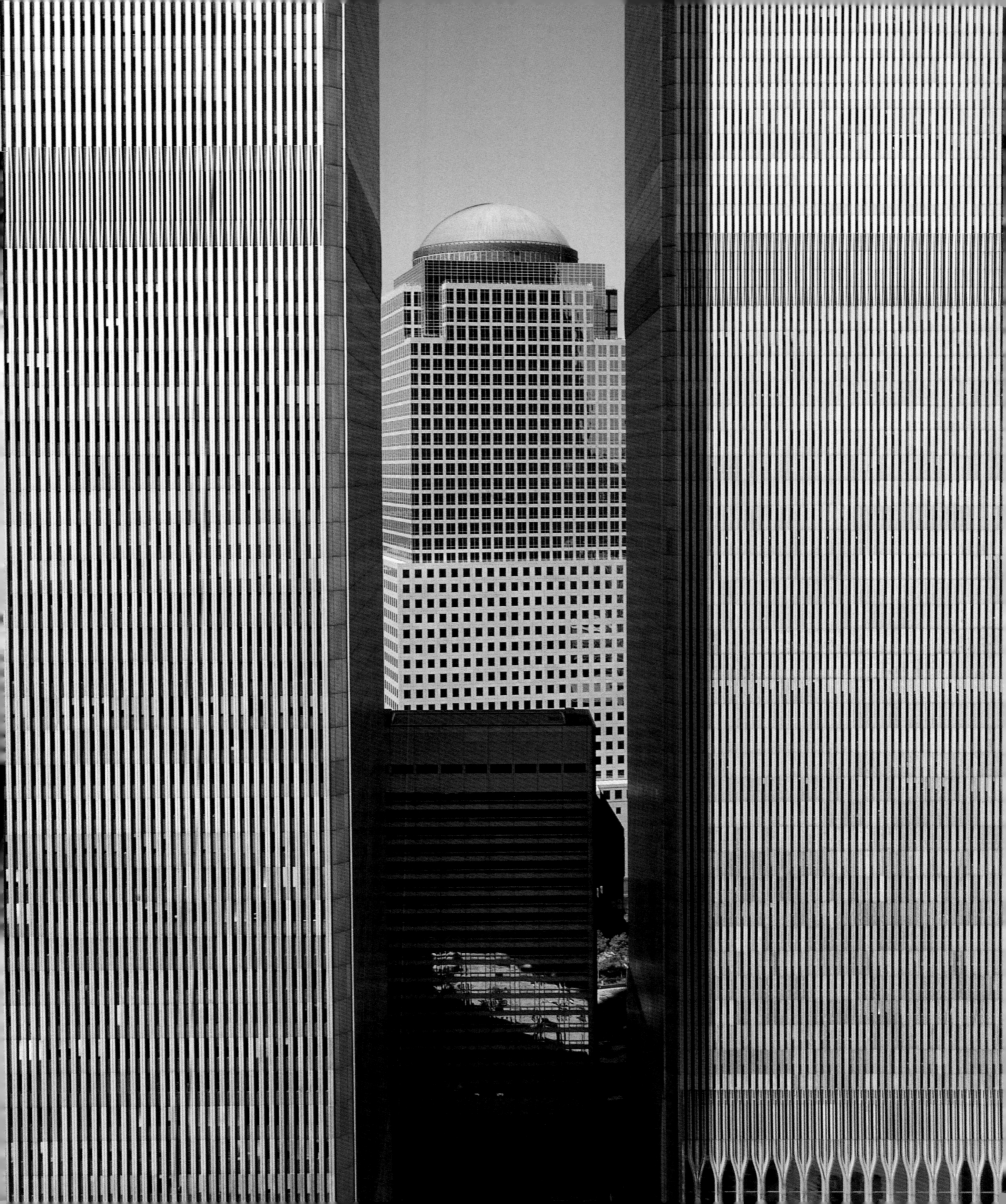

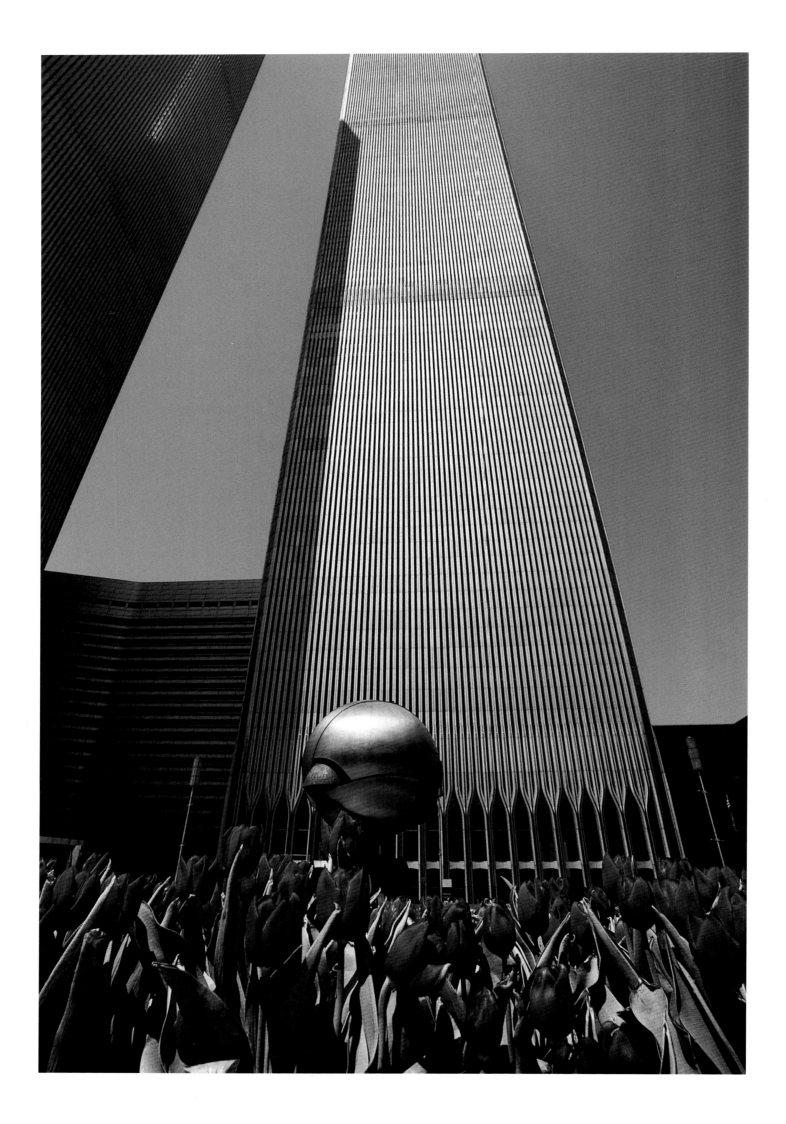

THE PLAZA

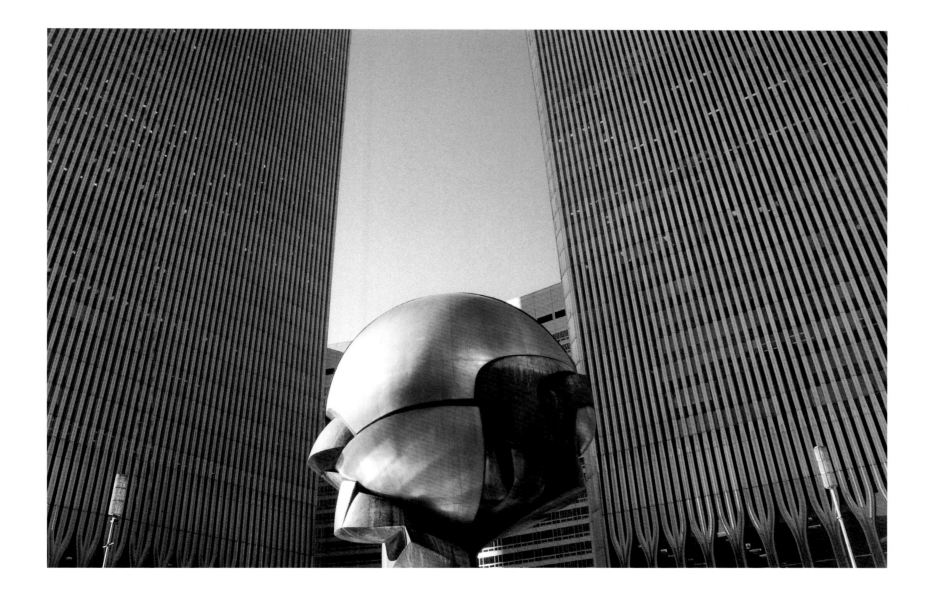

THE PLAZA

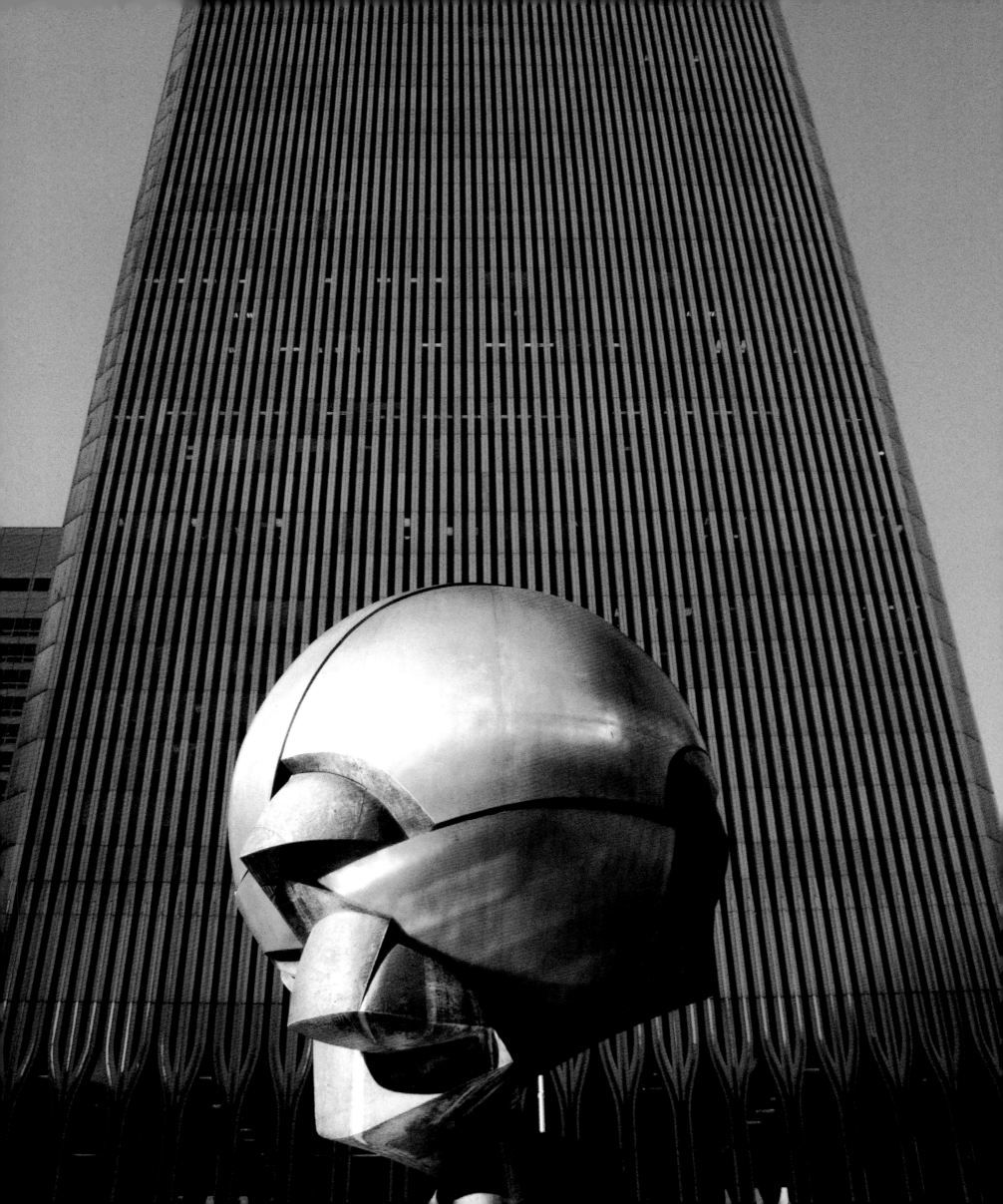

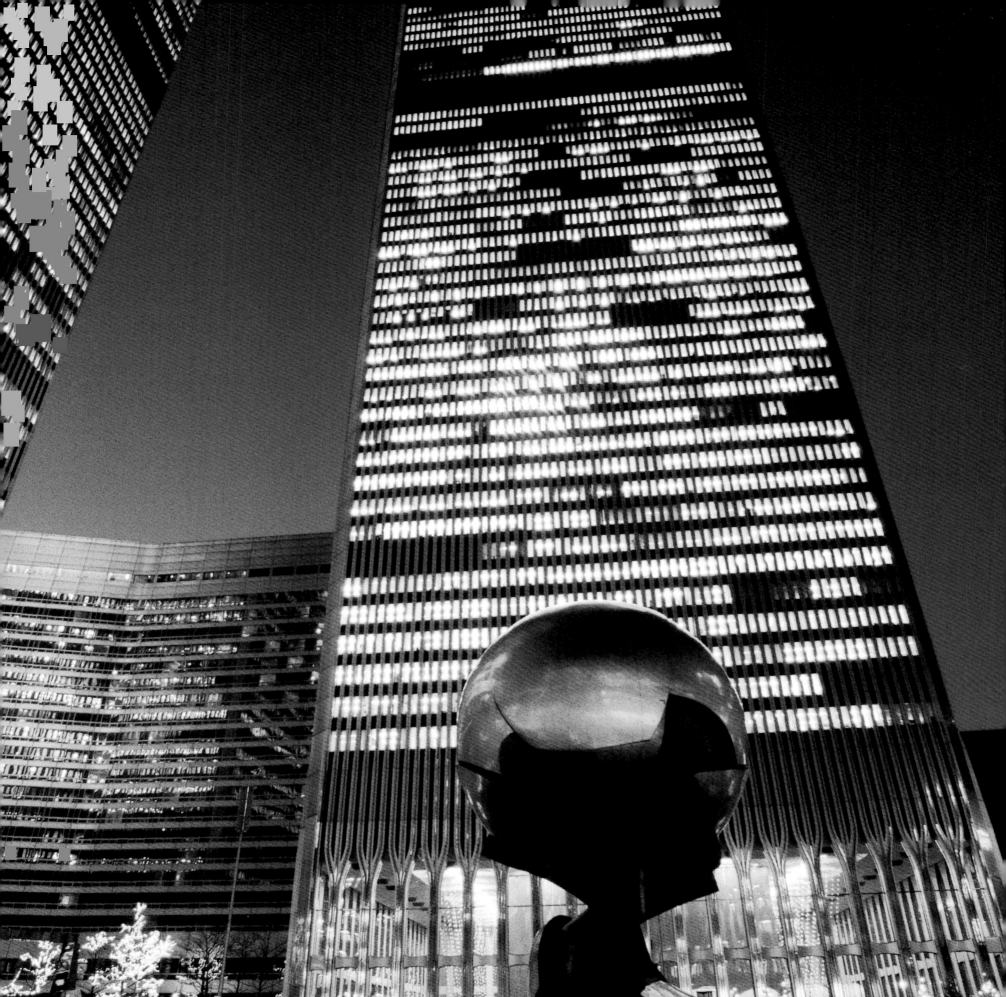

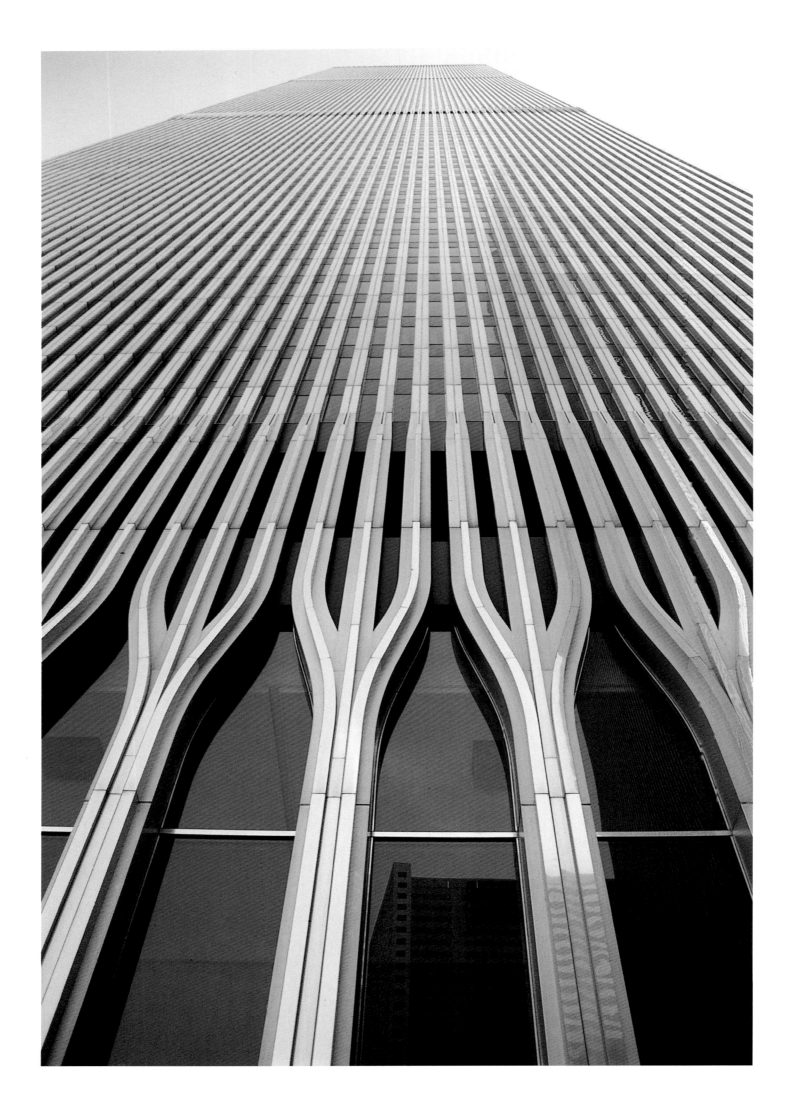

THE PLAZA

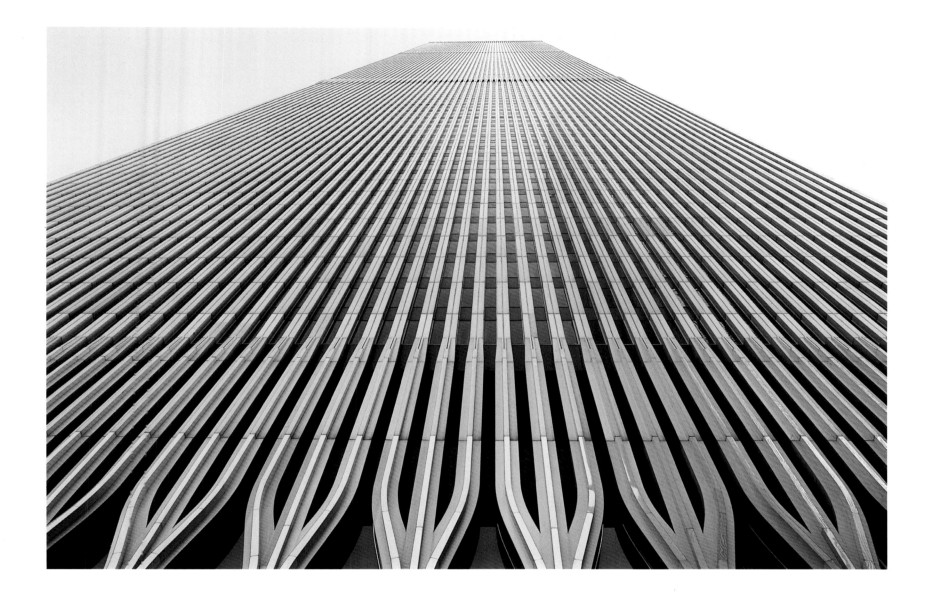

THE PLAZA

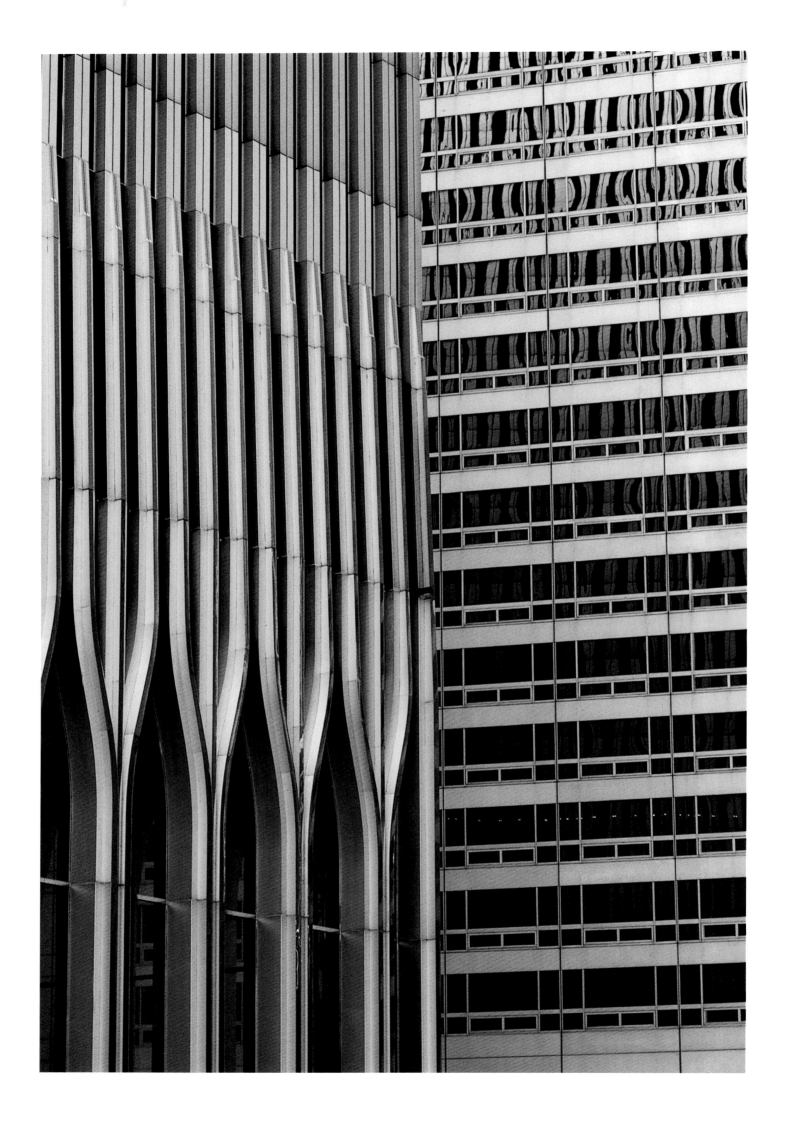

THE PLAZA

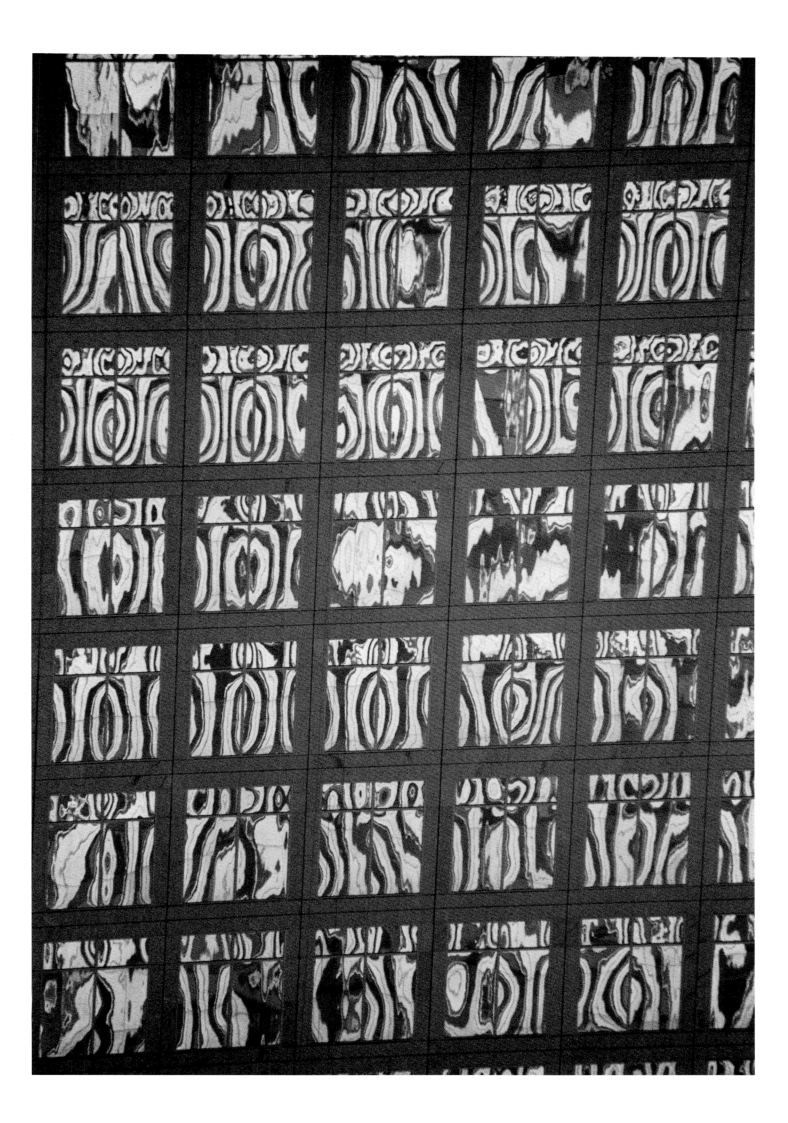

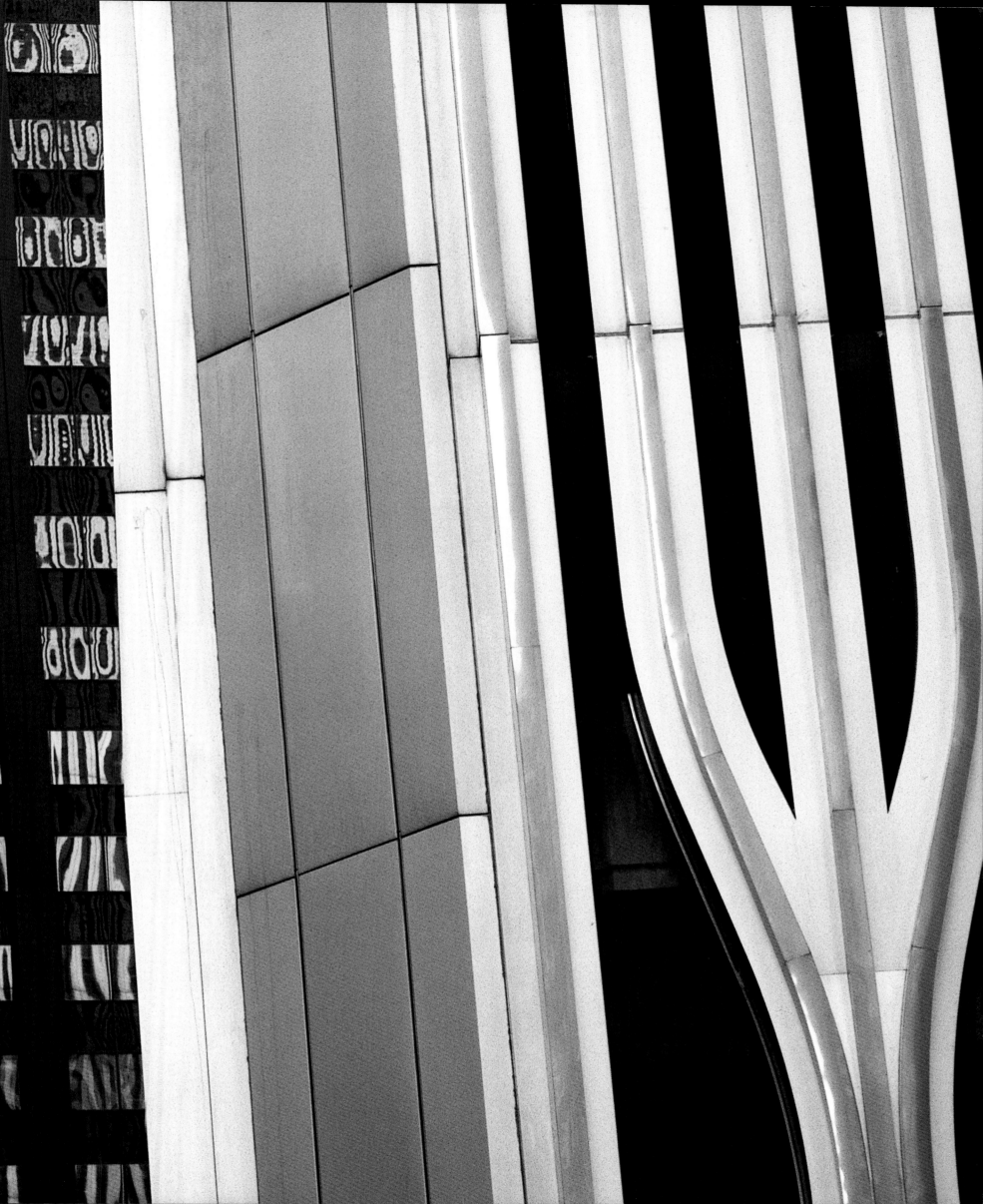

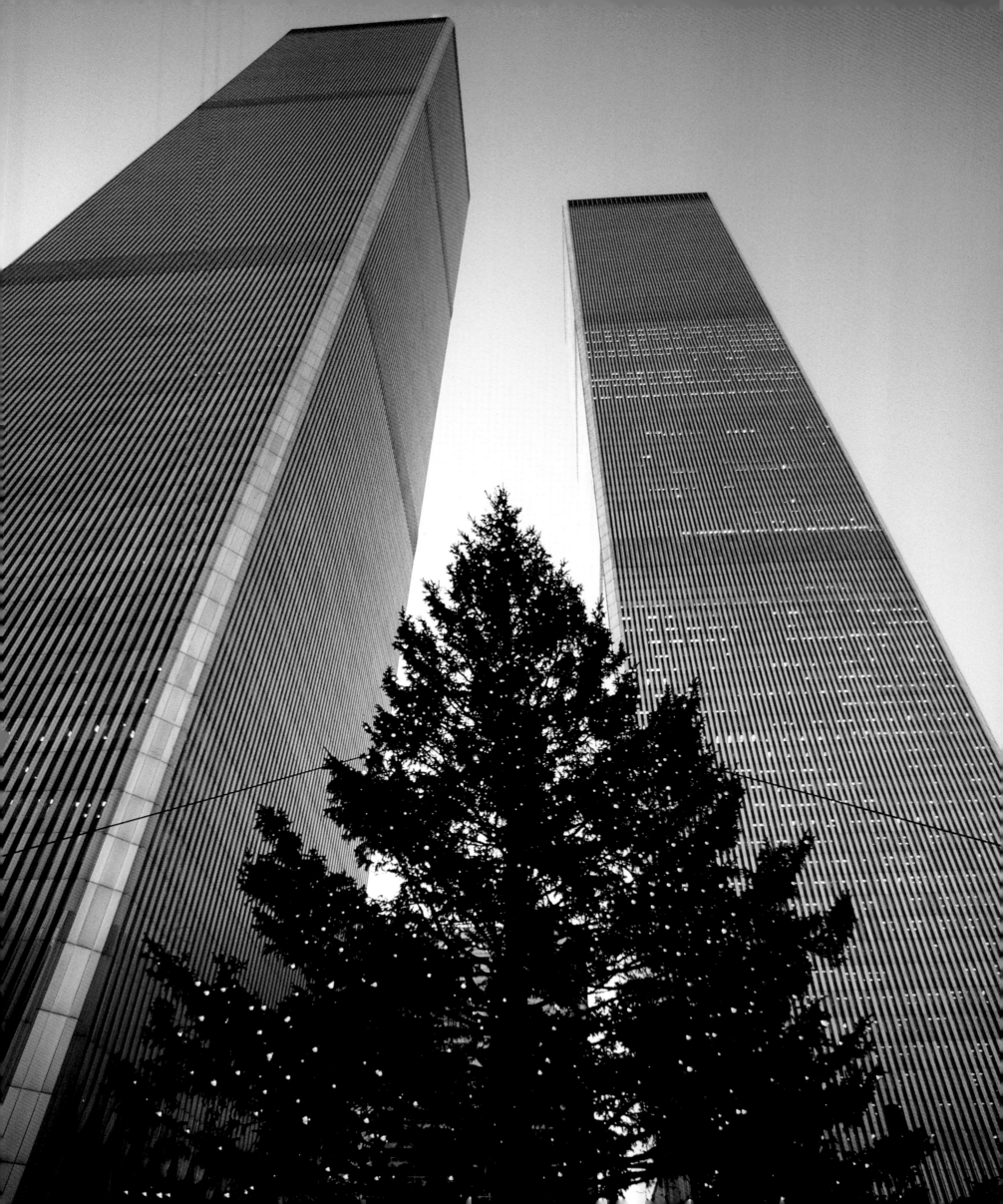

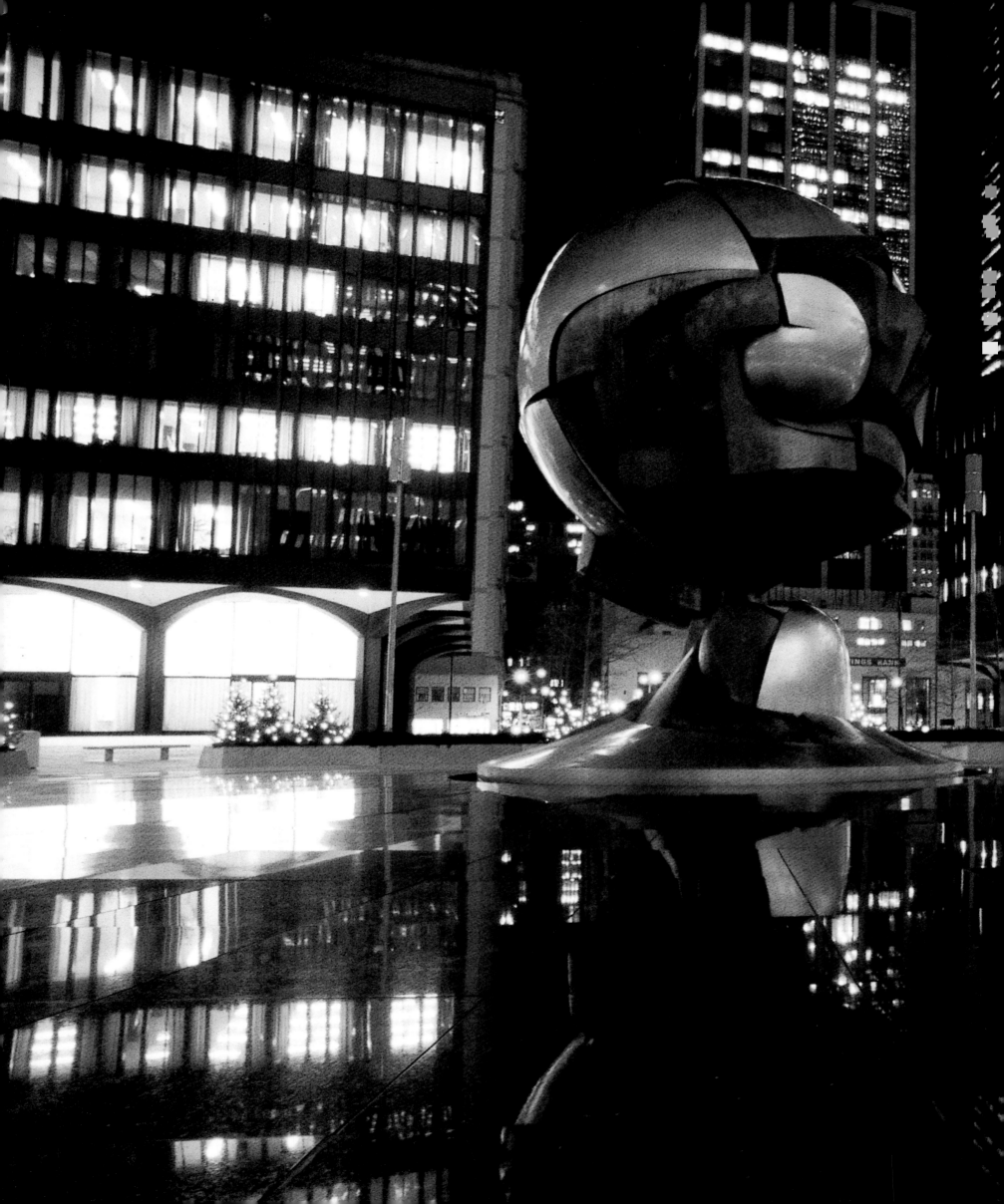

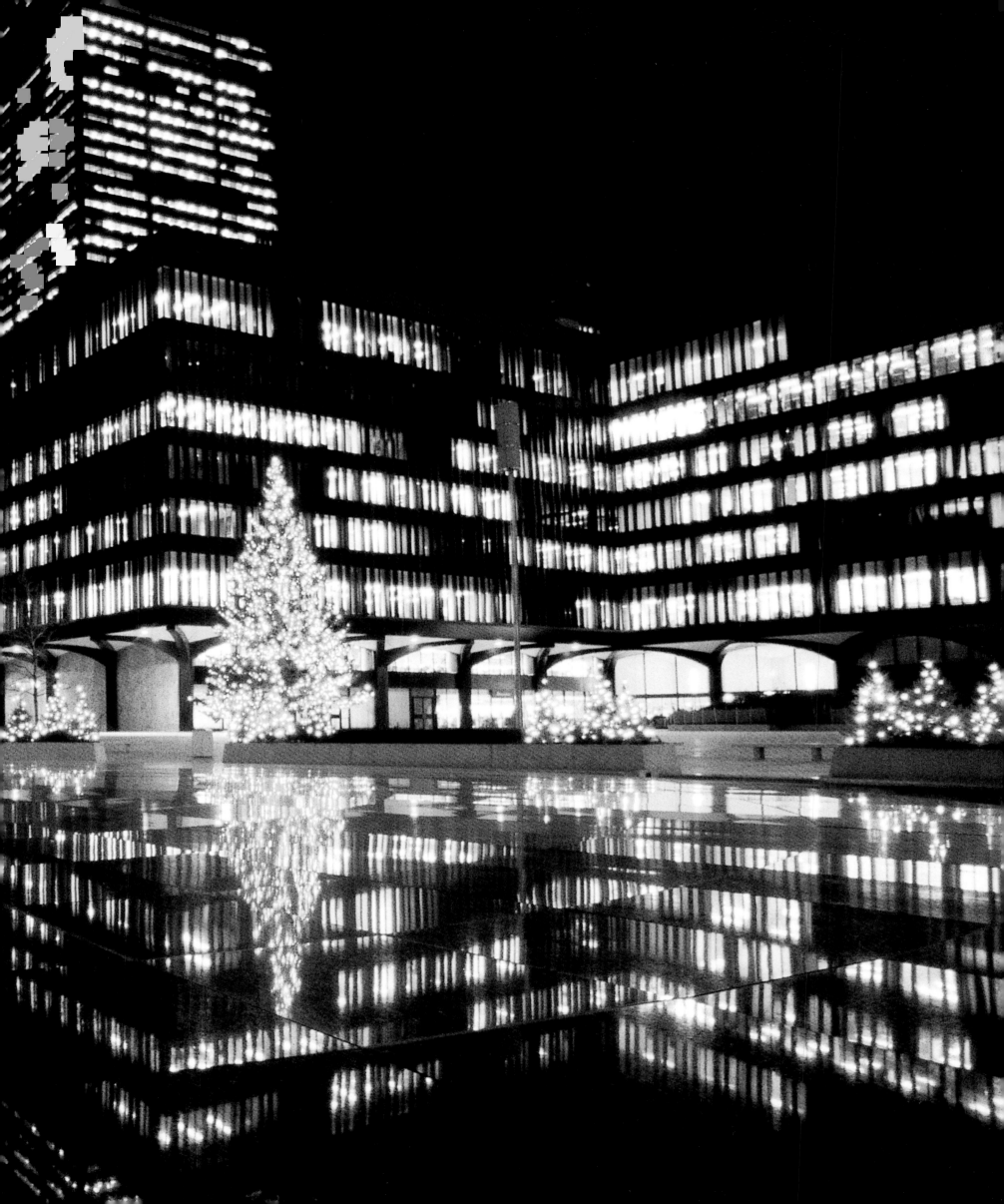

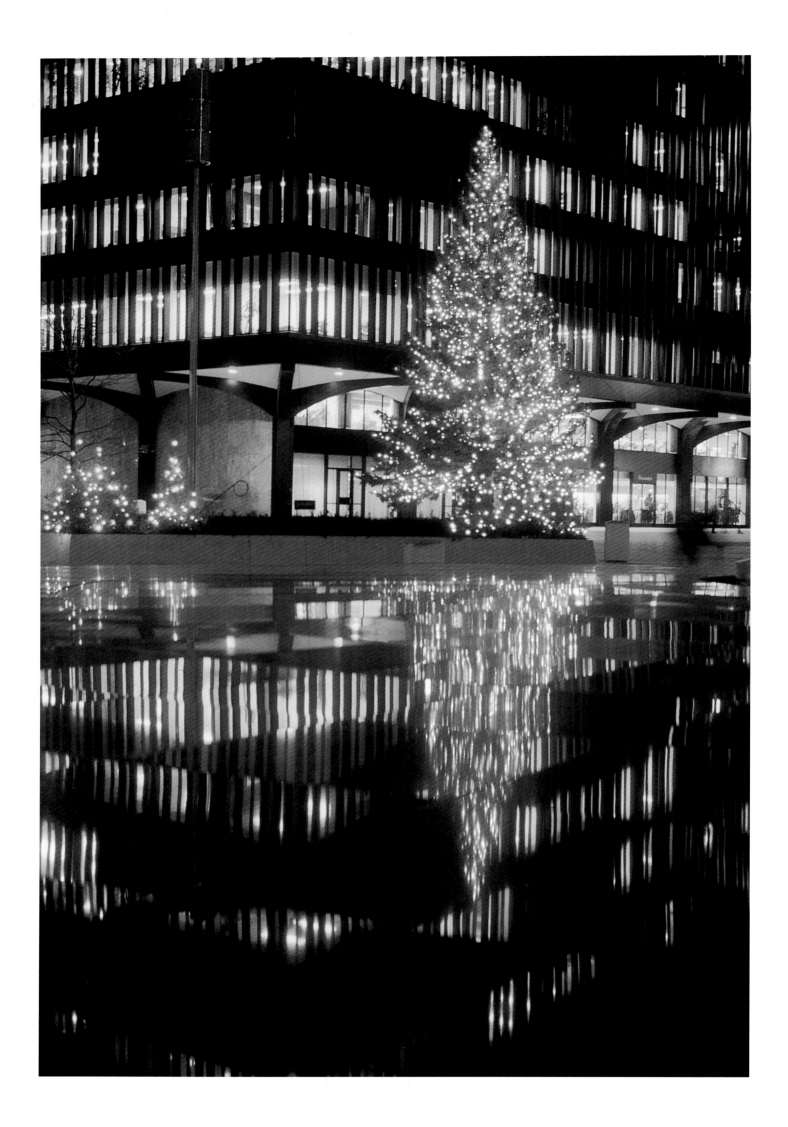

THE PLAZA

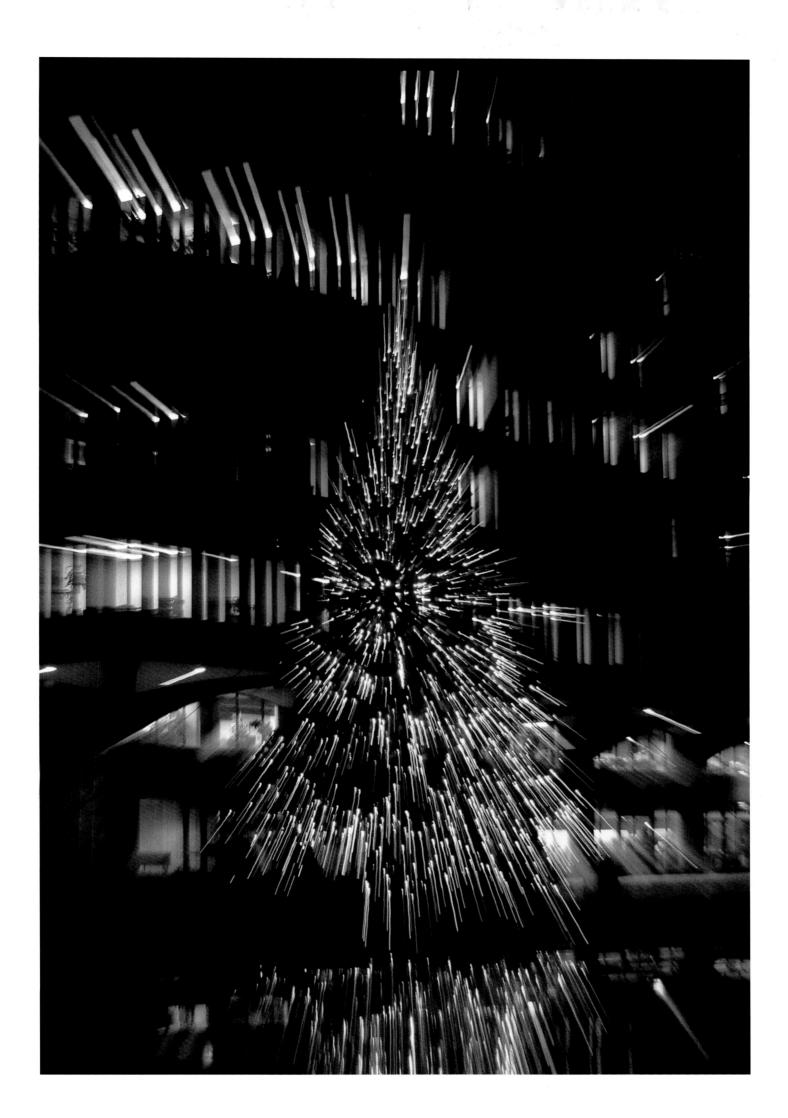

THE PLAZA

69

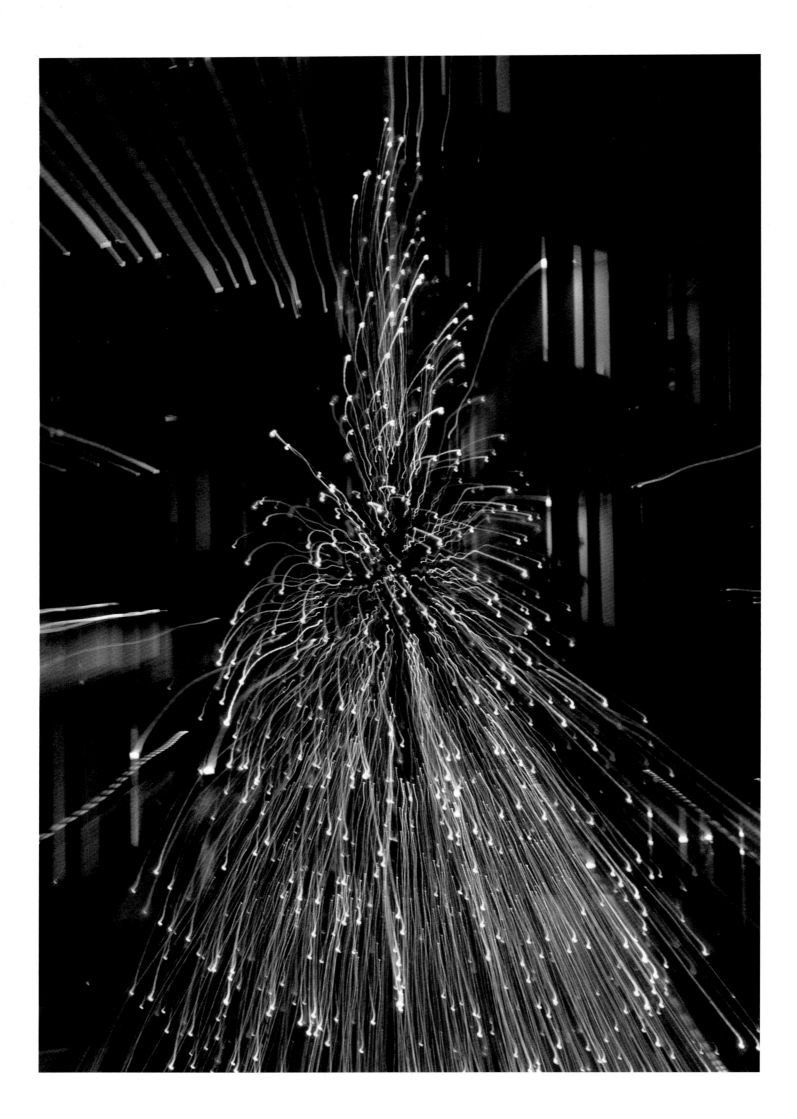

THE PLAZA

THE PLAZA

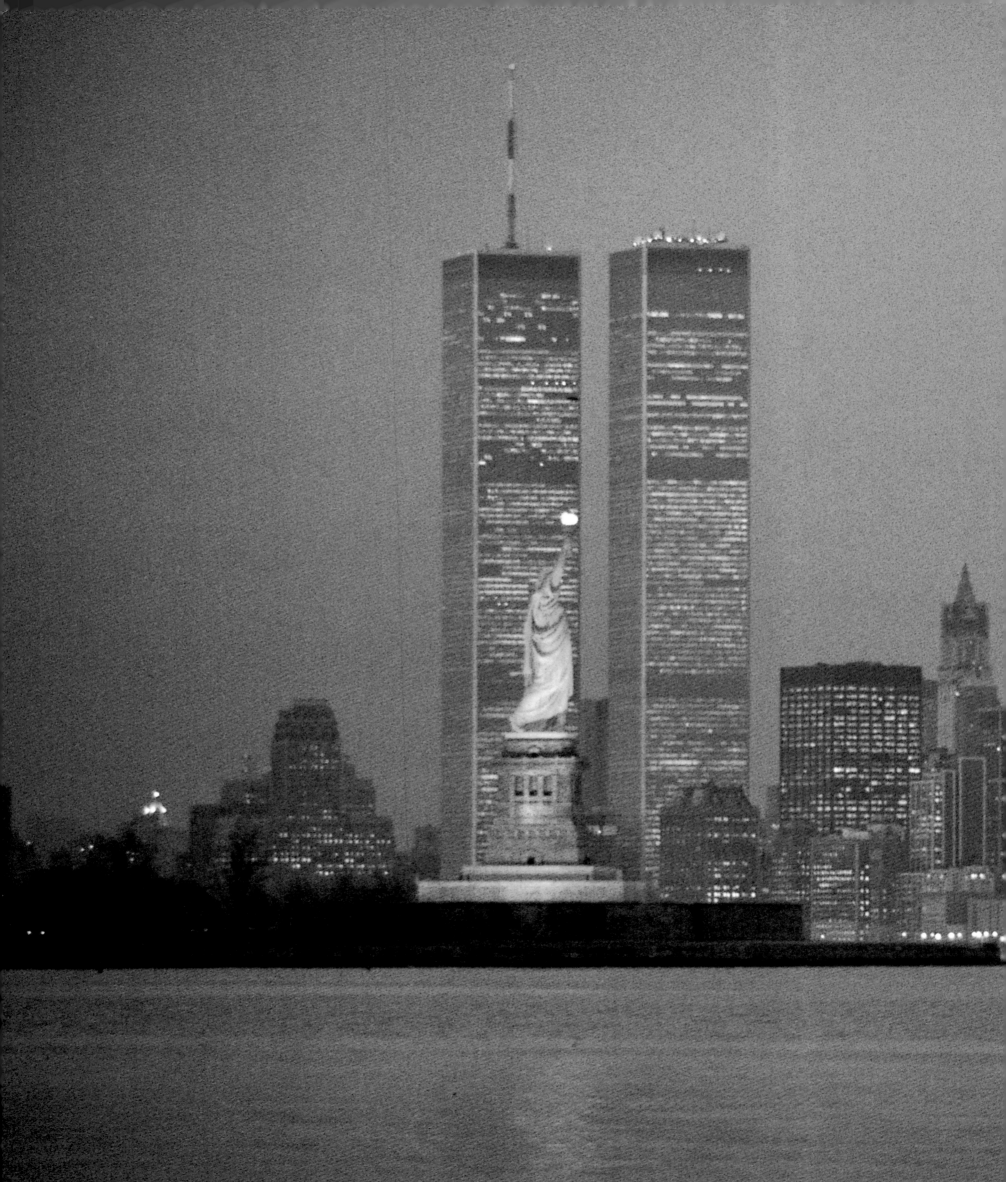

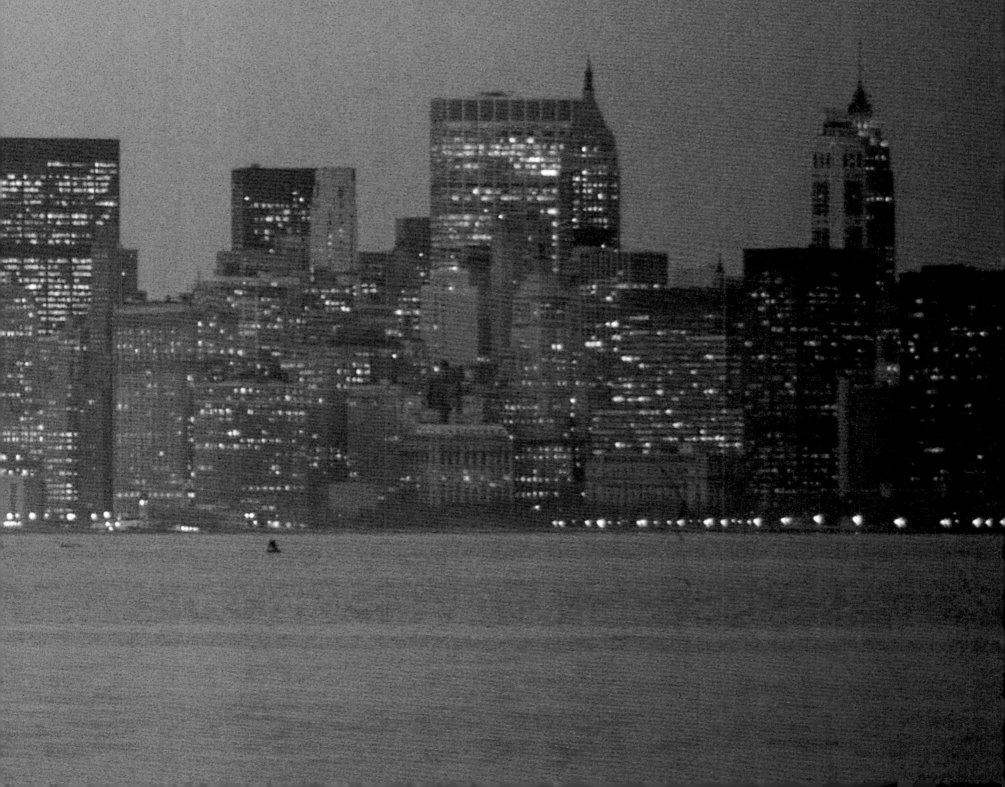

THE VIEW
LOOKING NORTH

THE VIEW
LOOKING NORTH

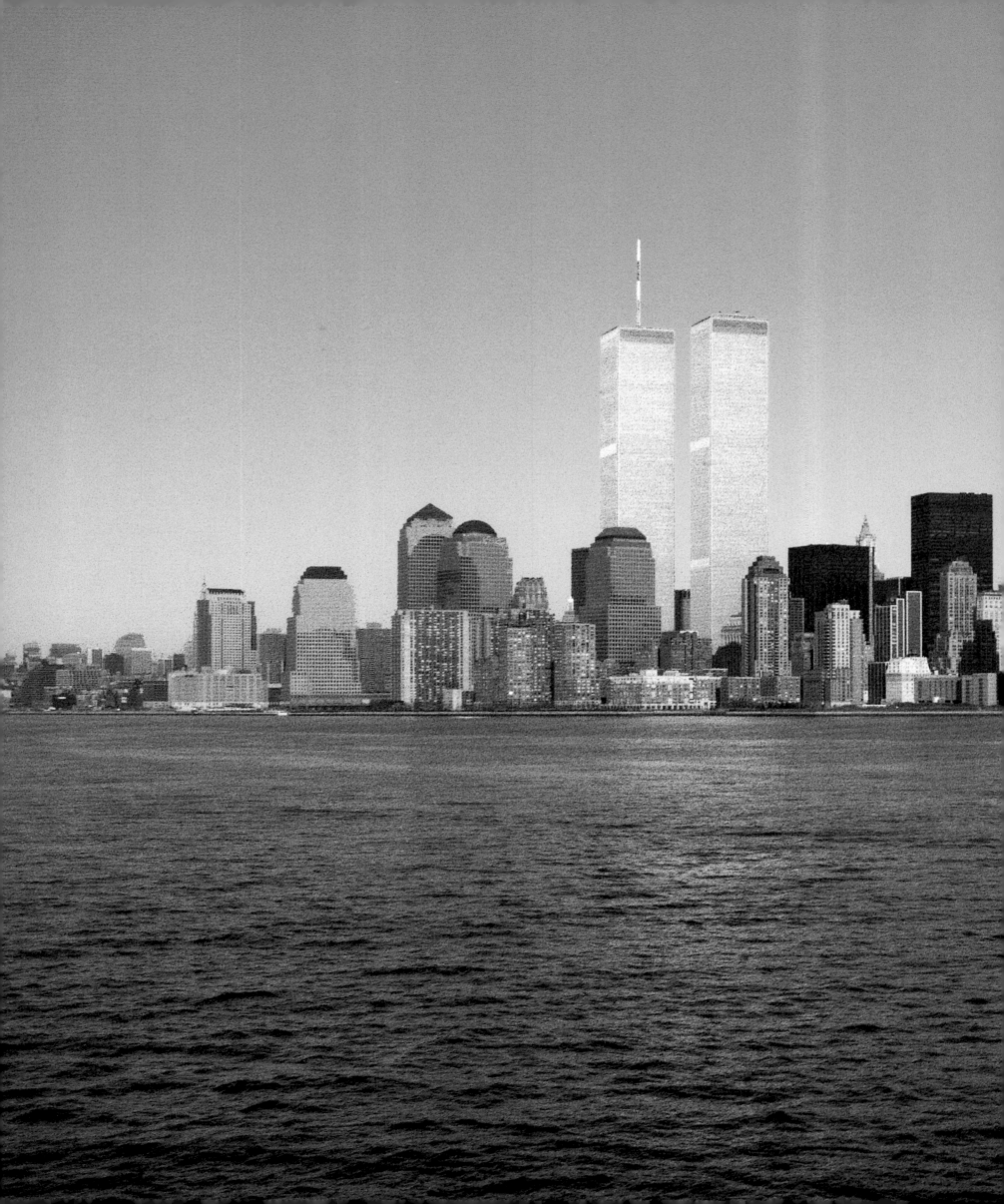

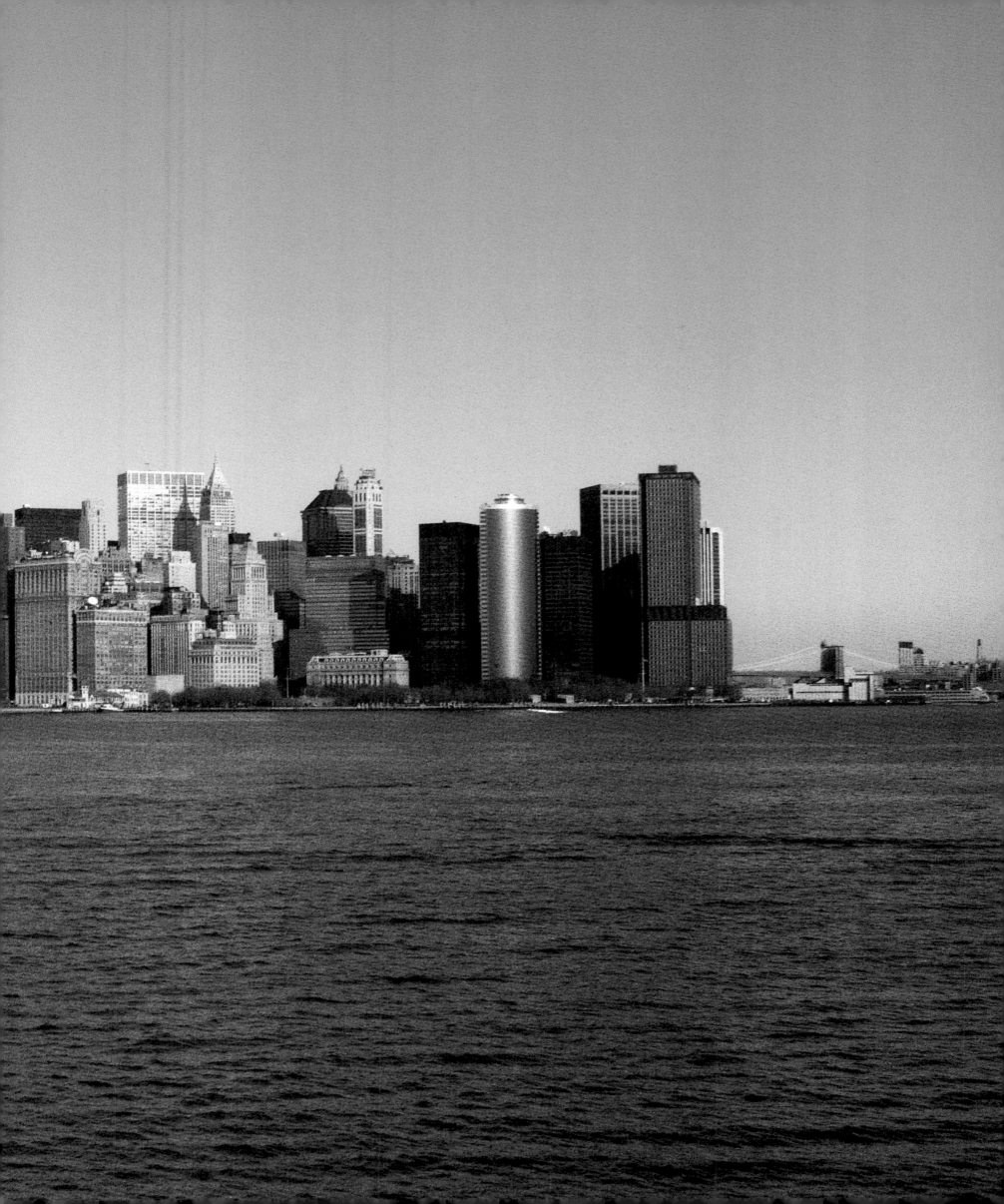

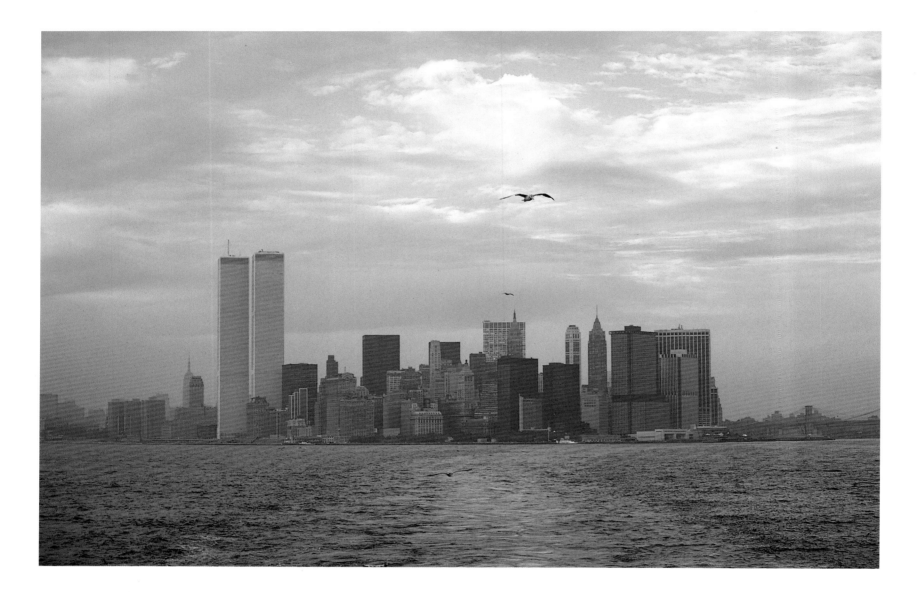

THE VIEW
LOOKING NORTH

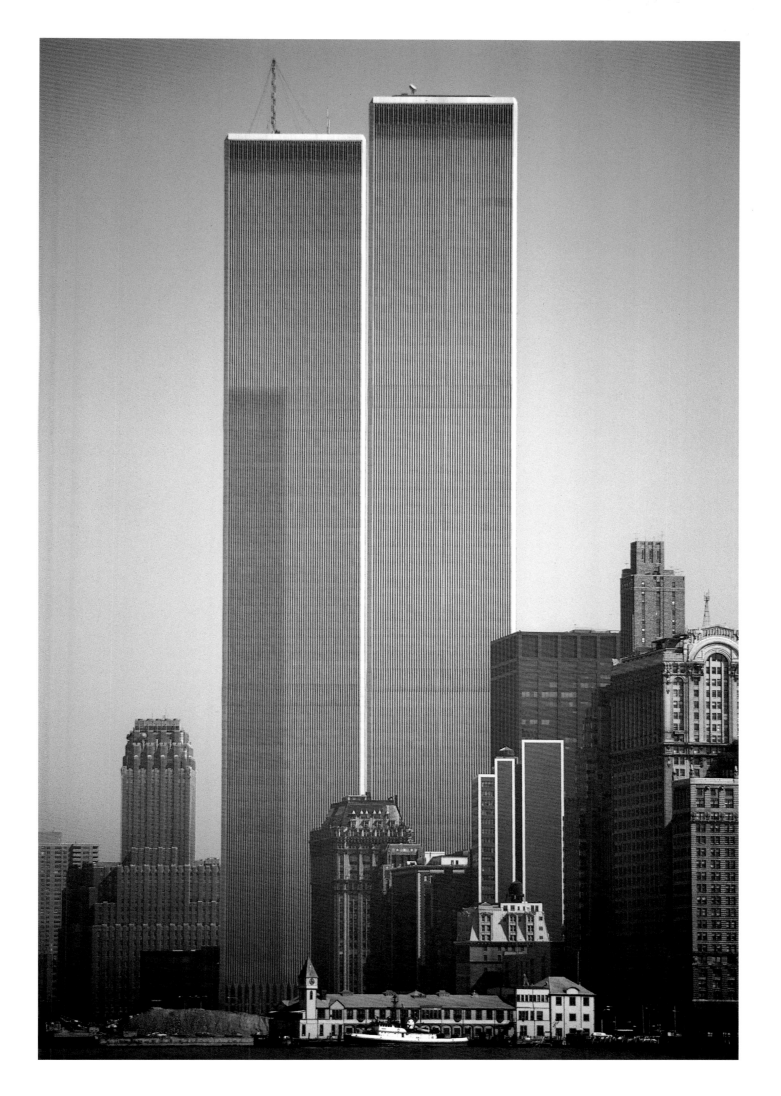

THE VIEW
LOOKING NORTH

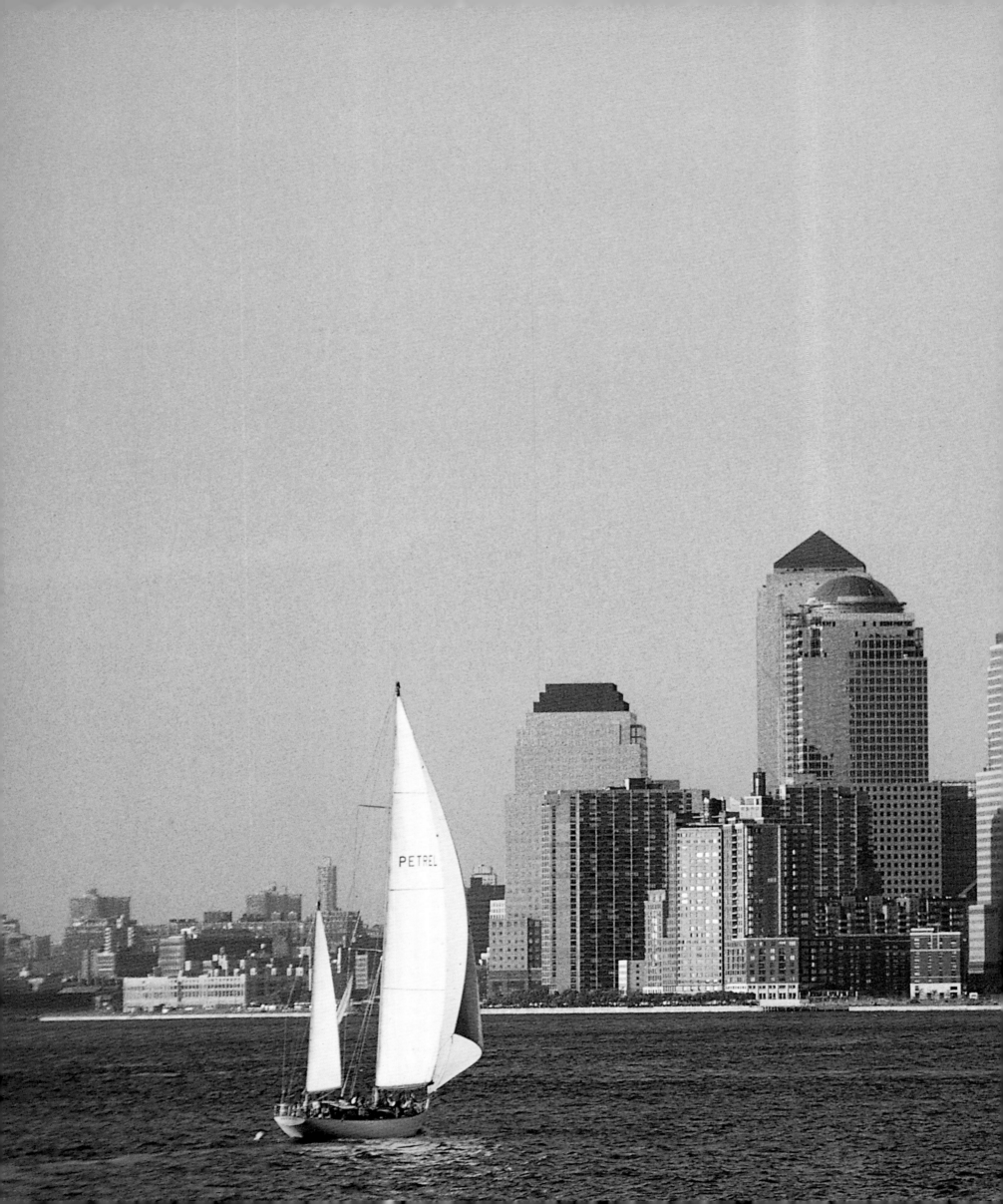

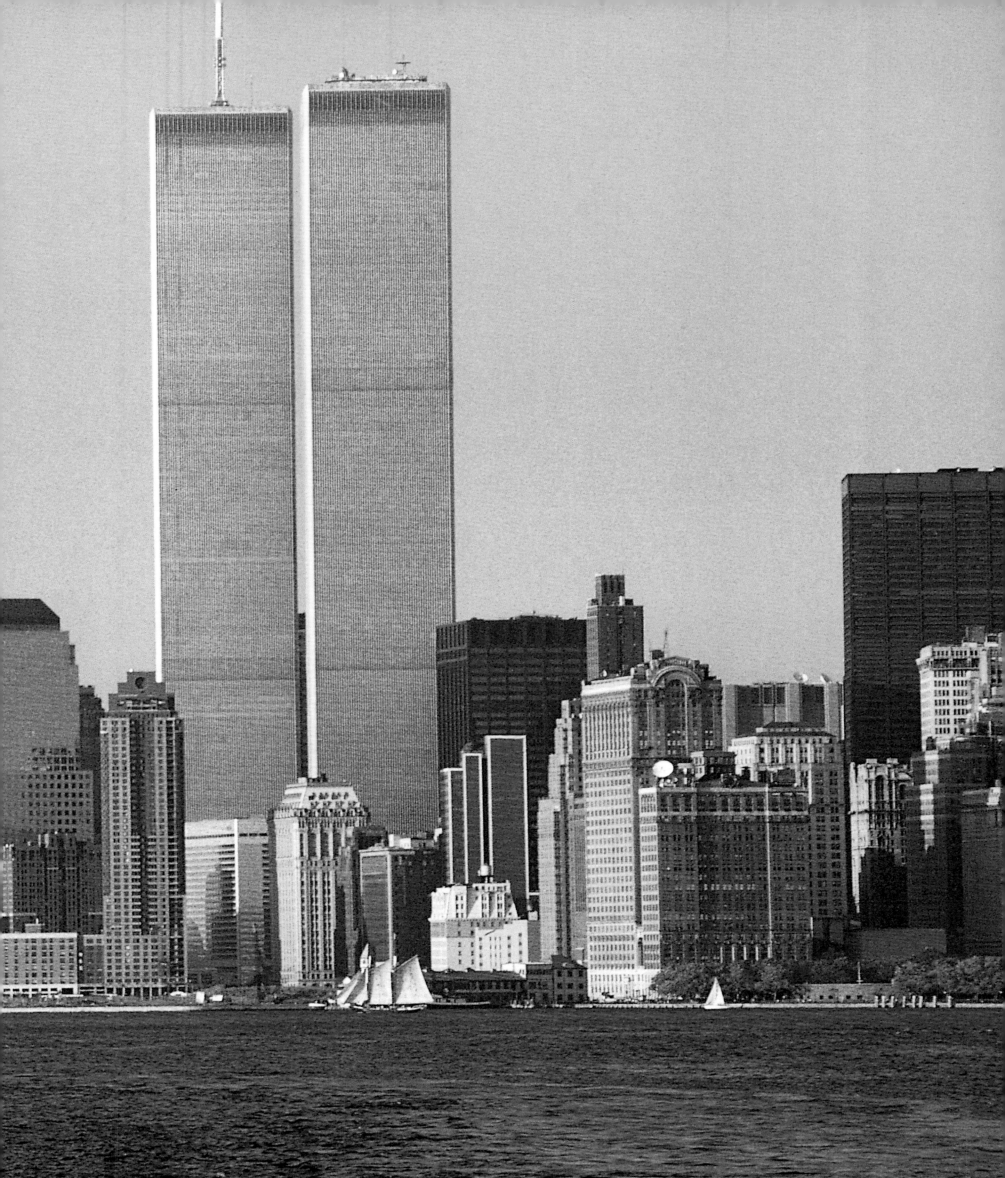

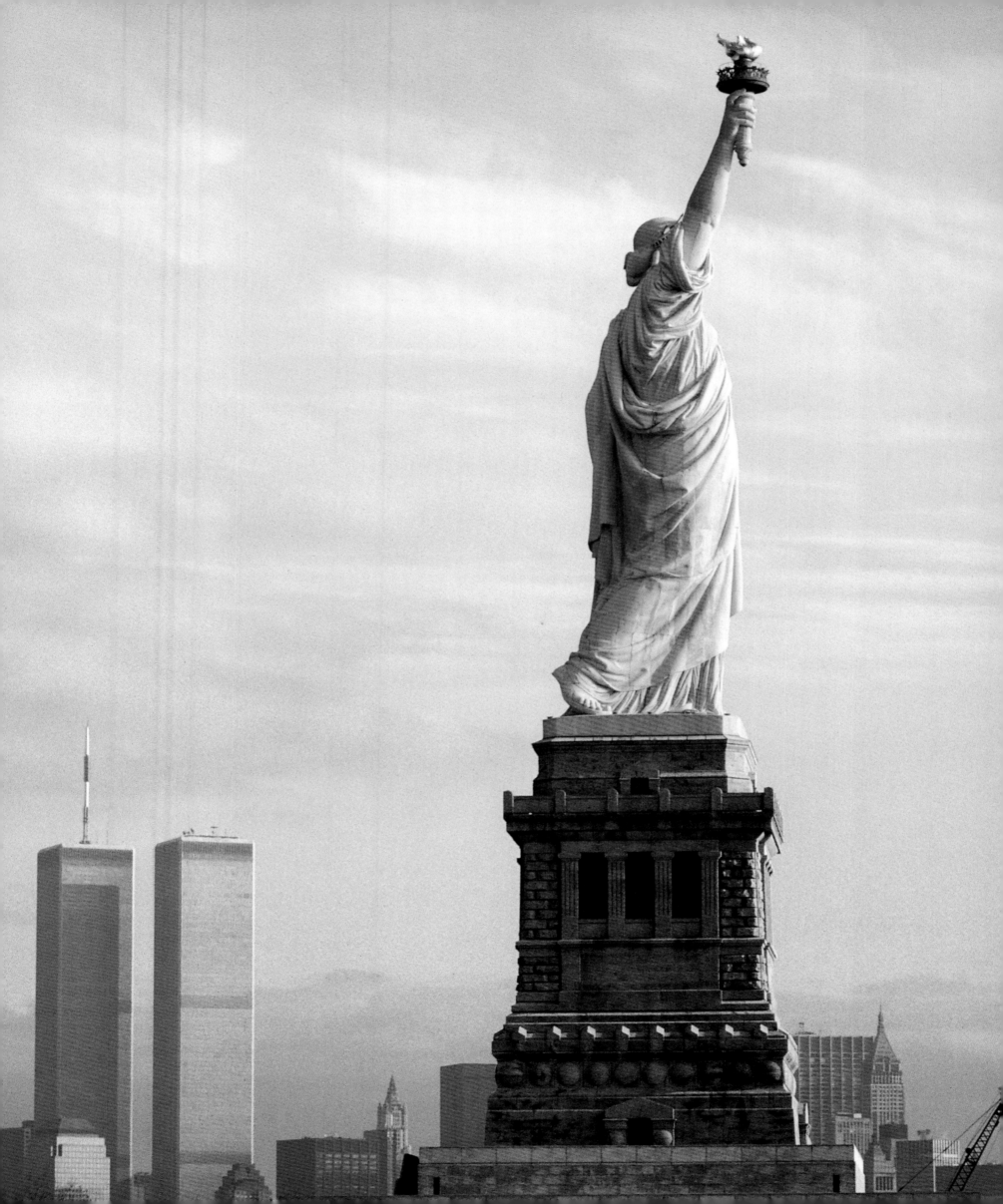

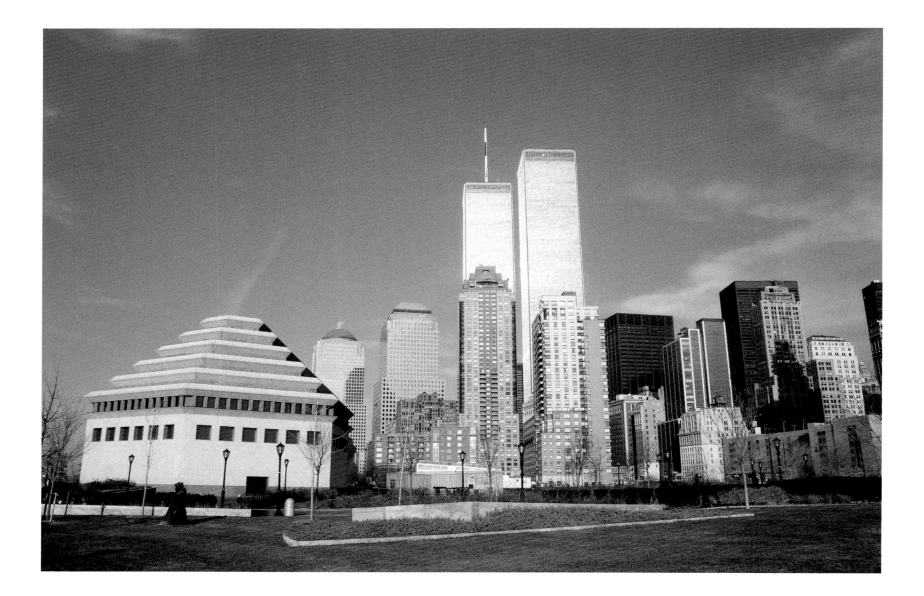

THE VIEW
LOOKING NORTH

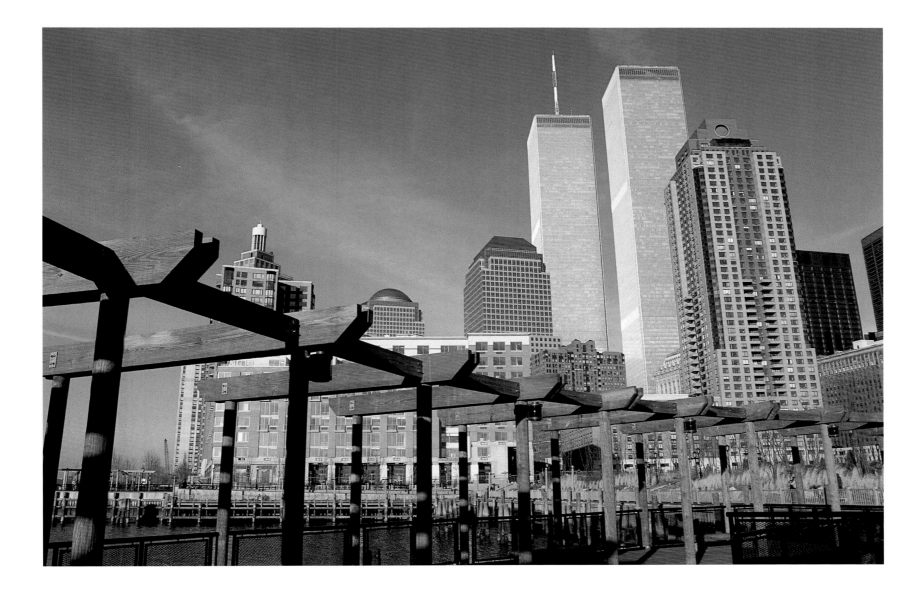

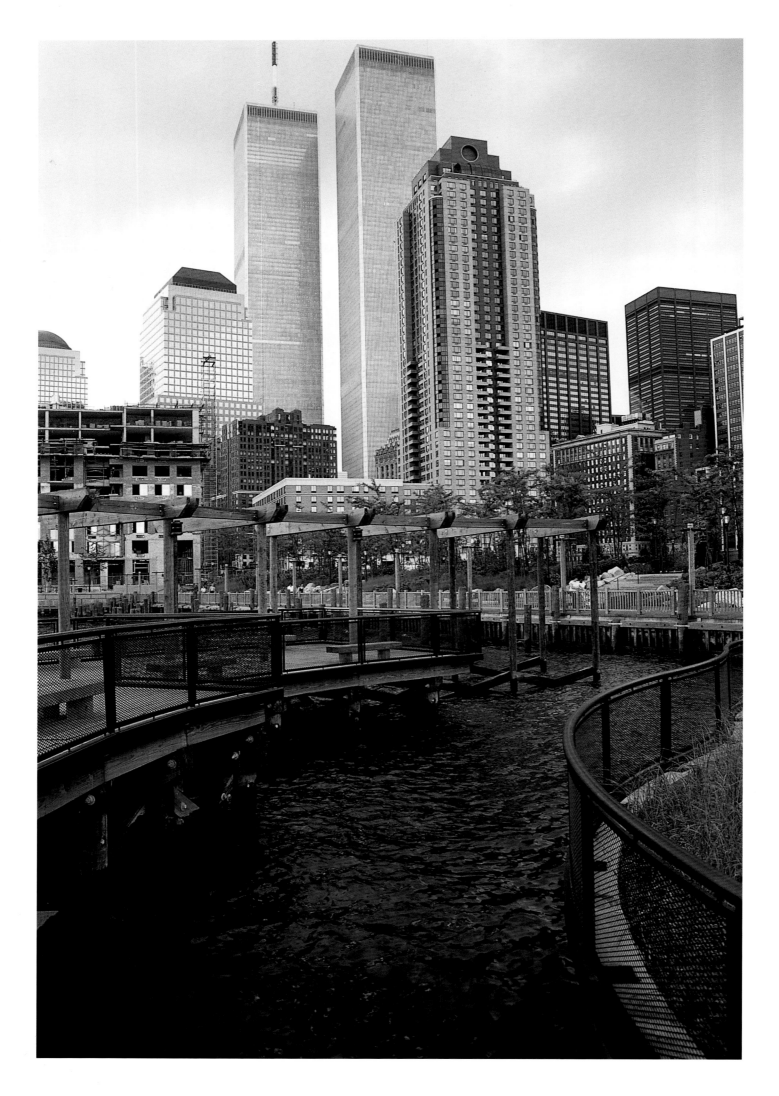

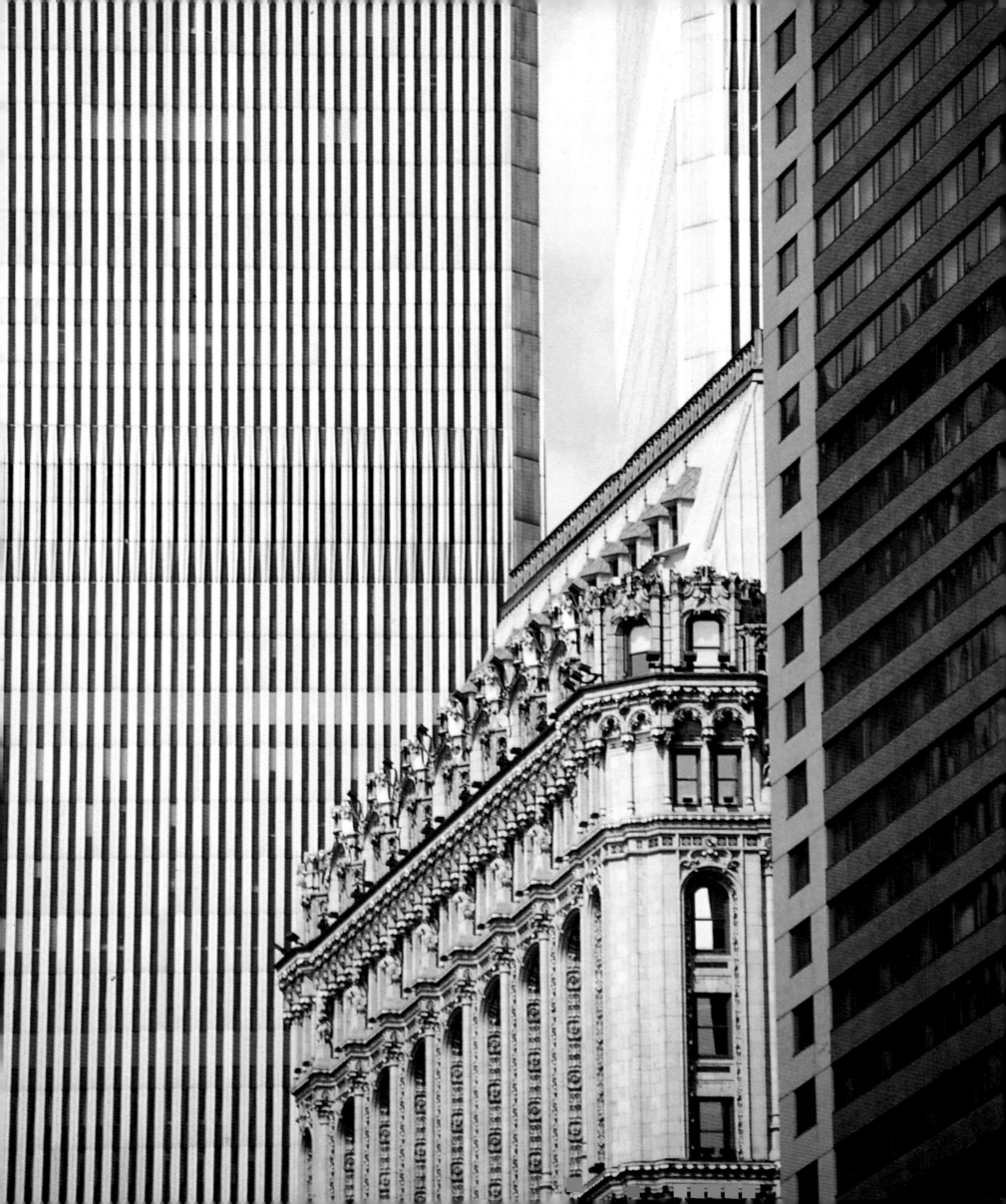

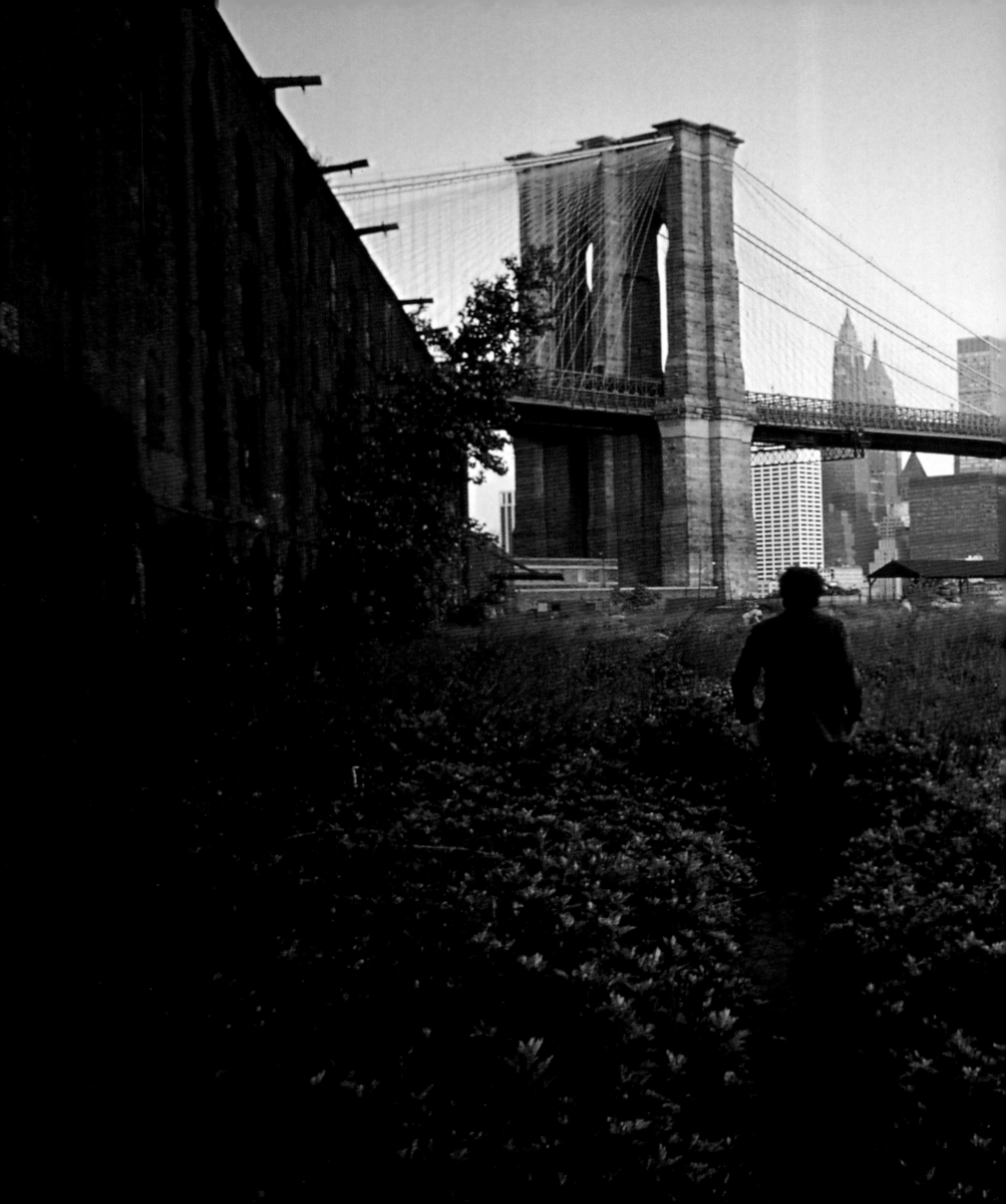

THE VIEW
LOOKING WEST

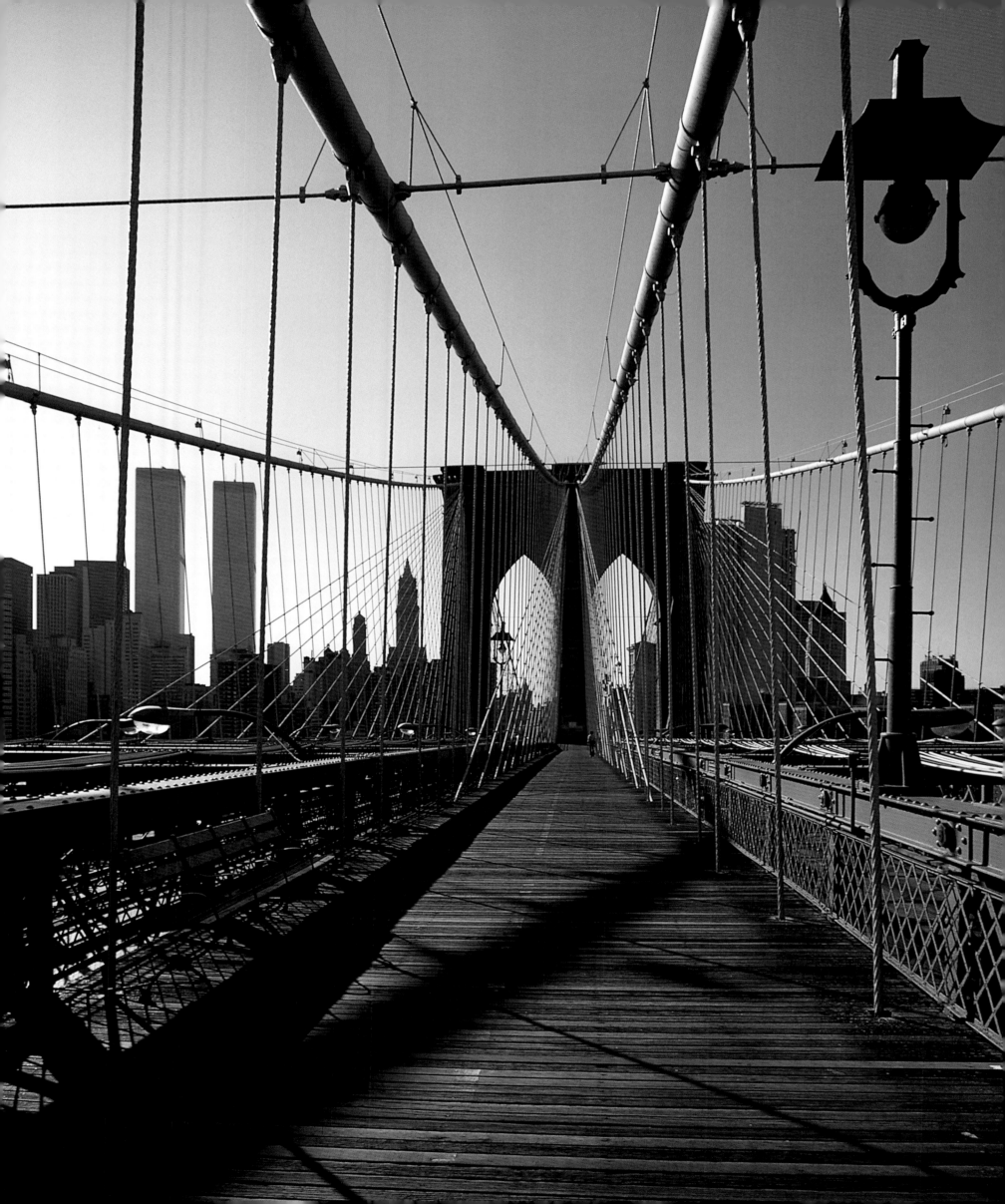

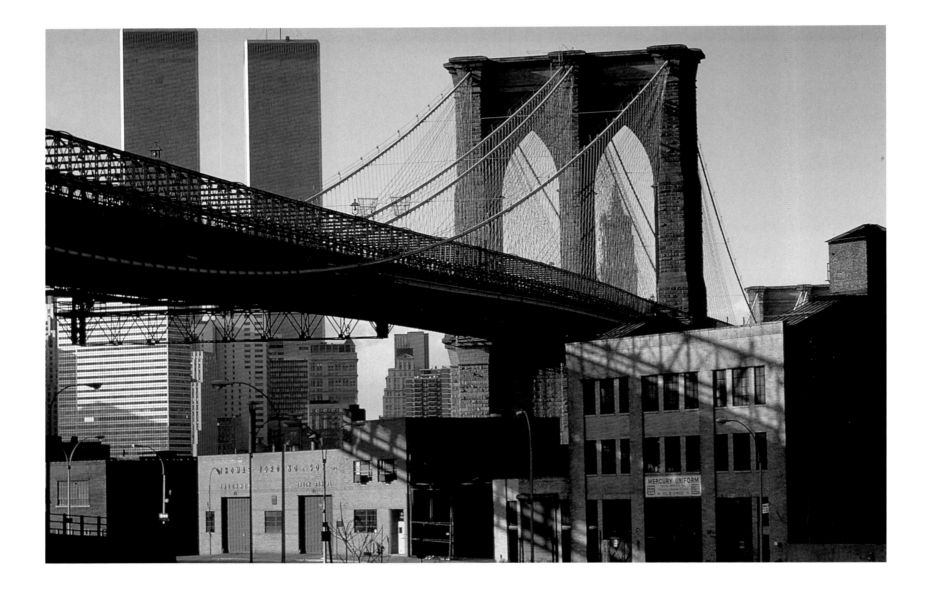

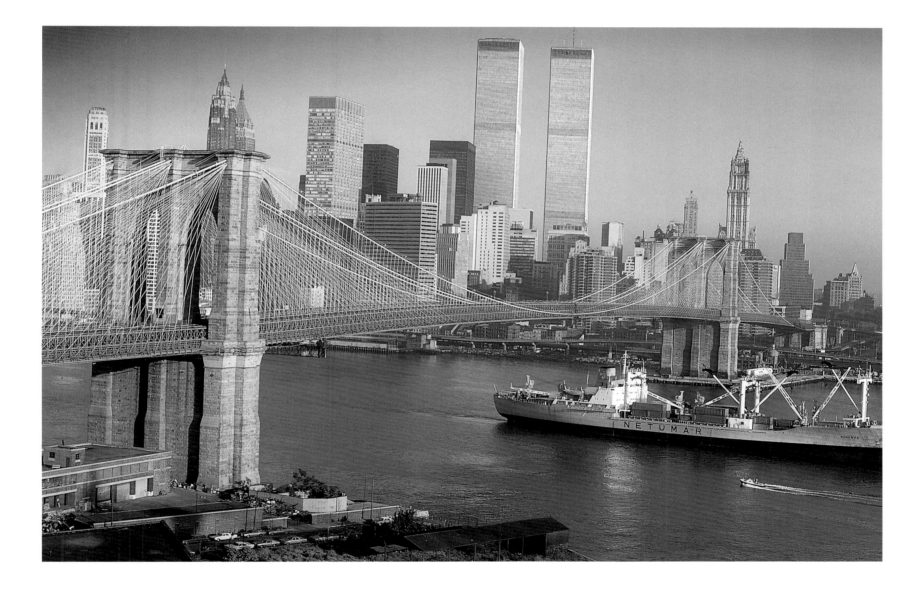

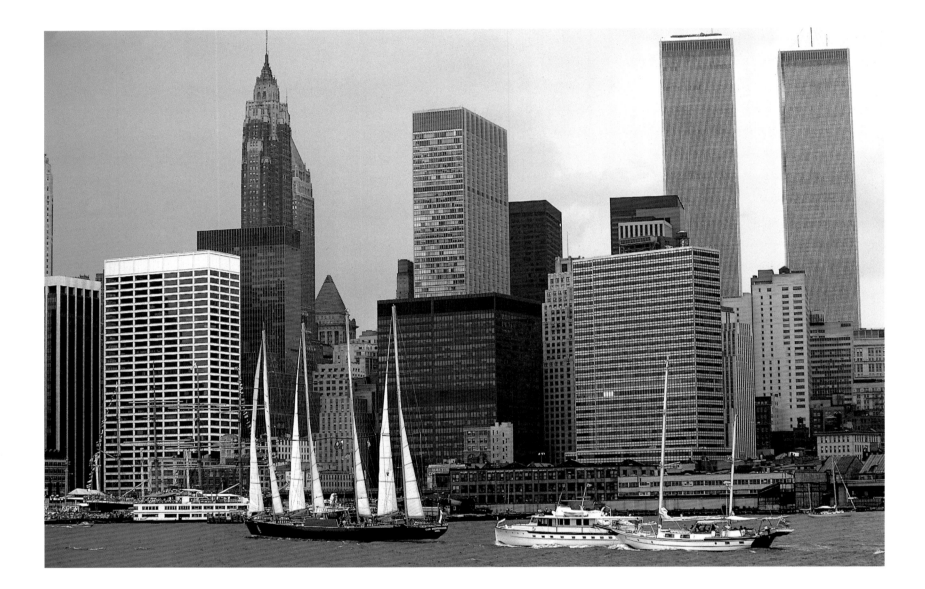

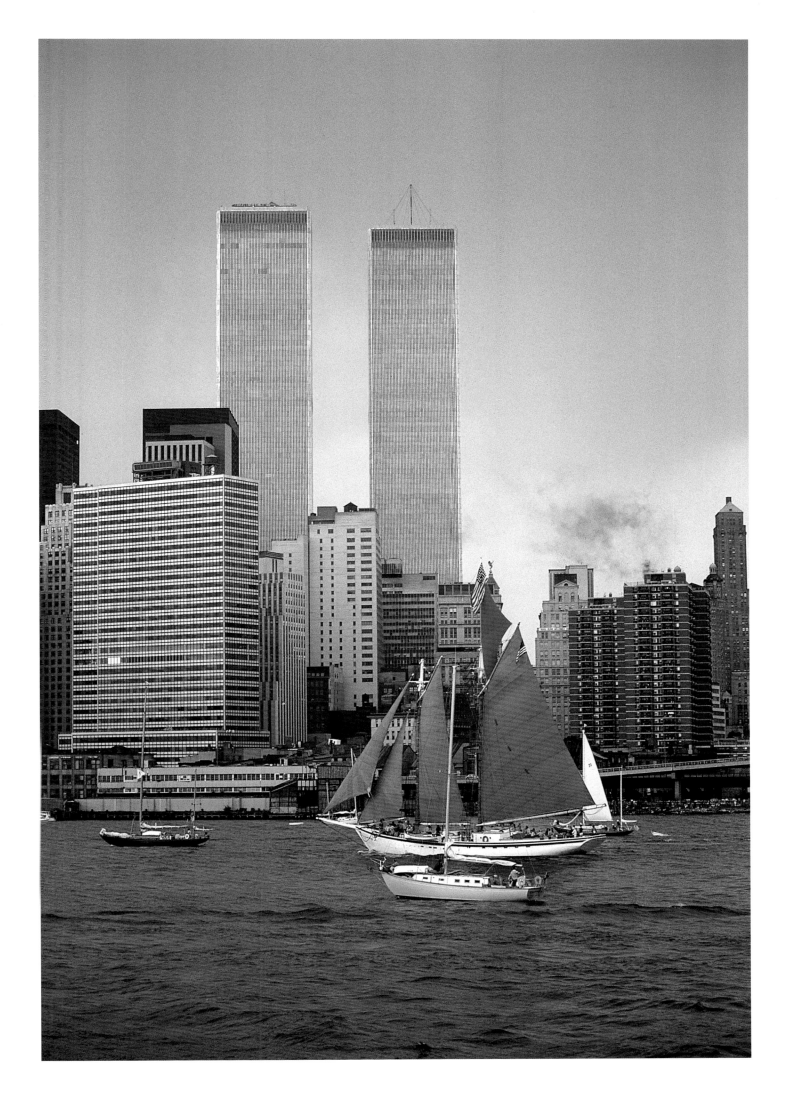

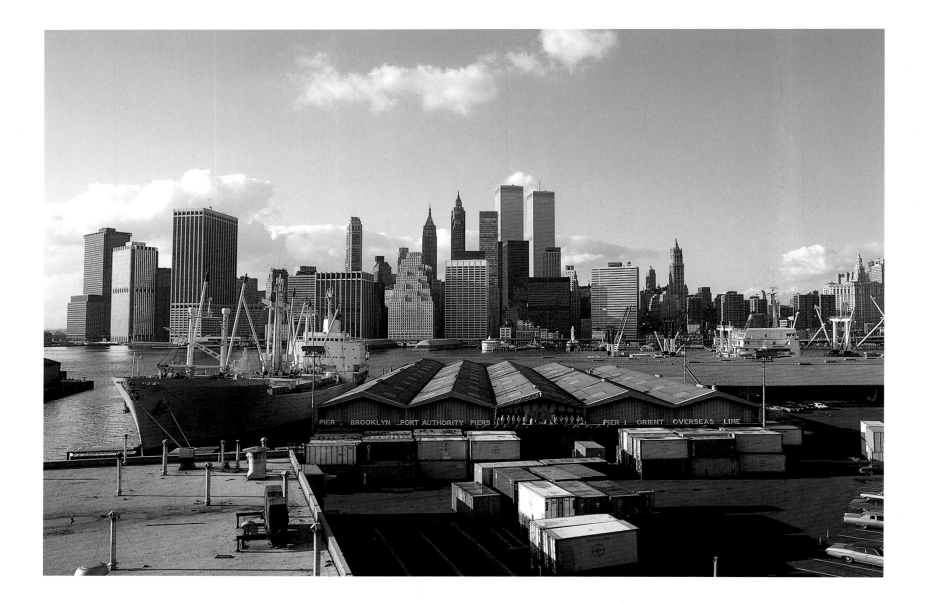

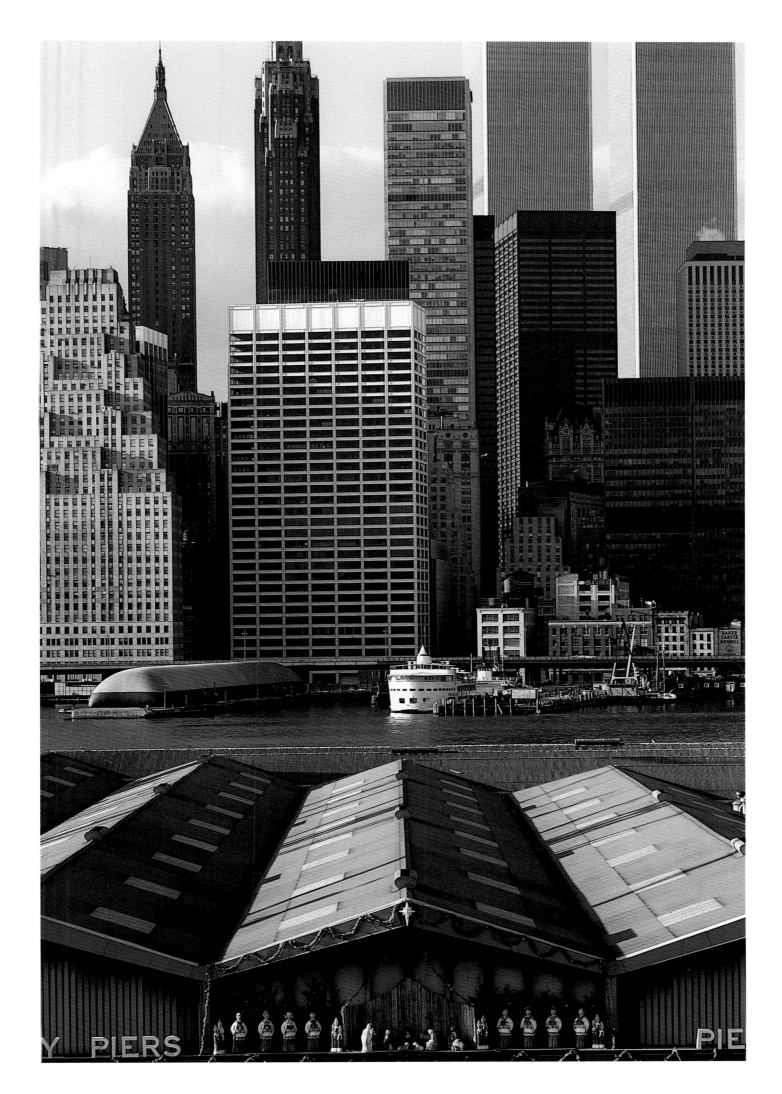

THE VIEW
LOOKING WEST

97

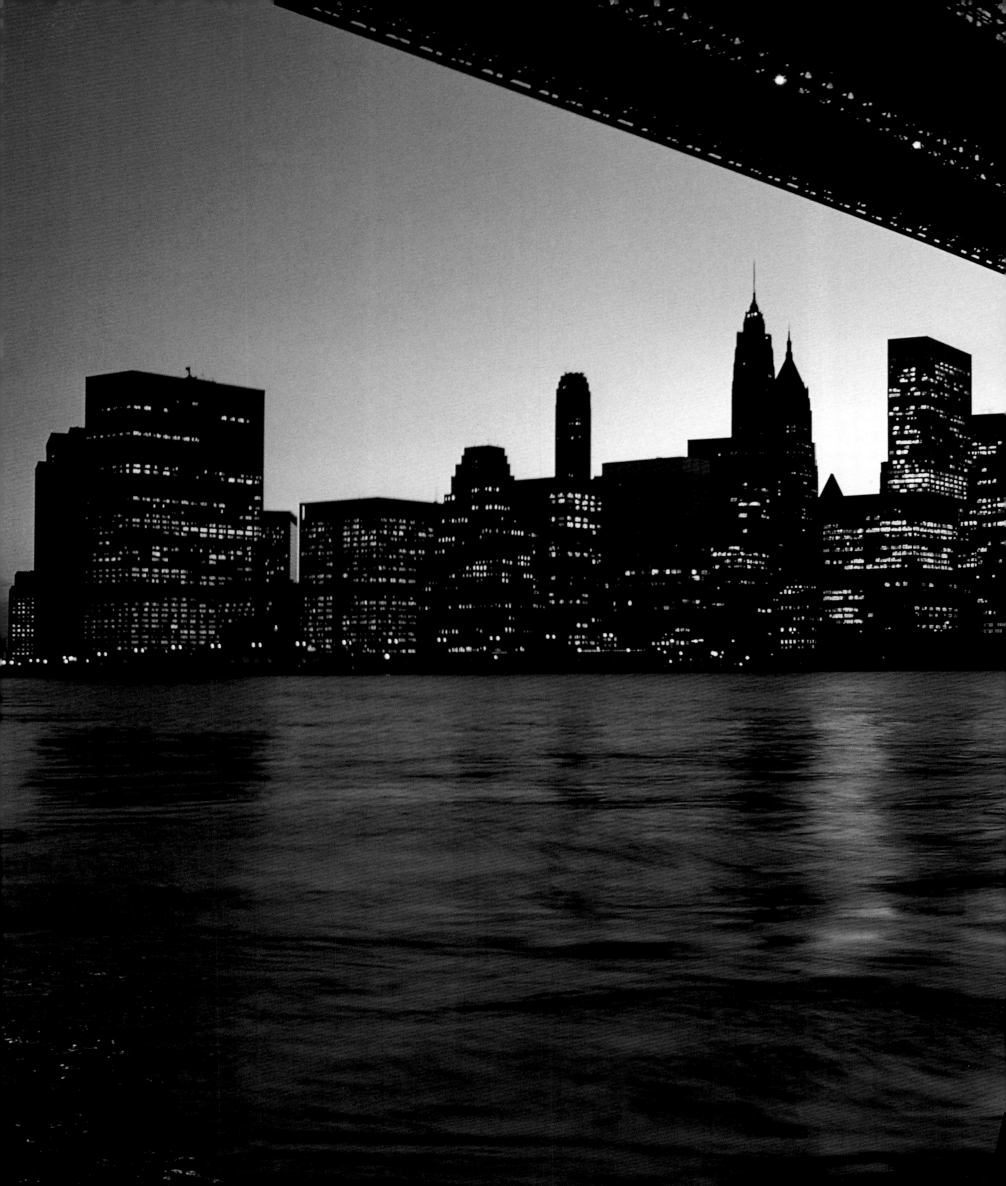

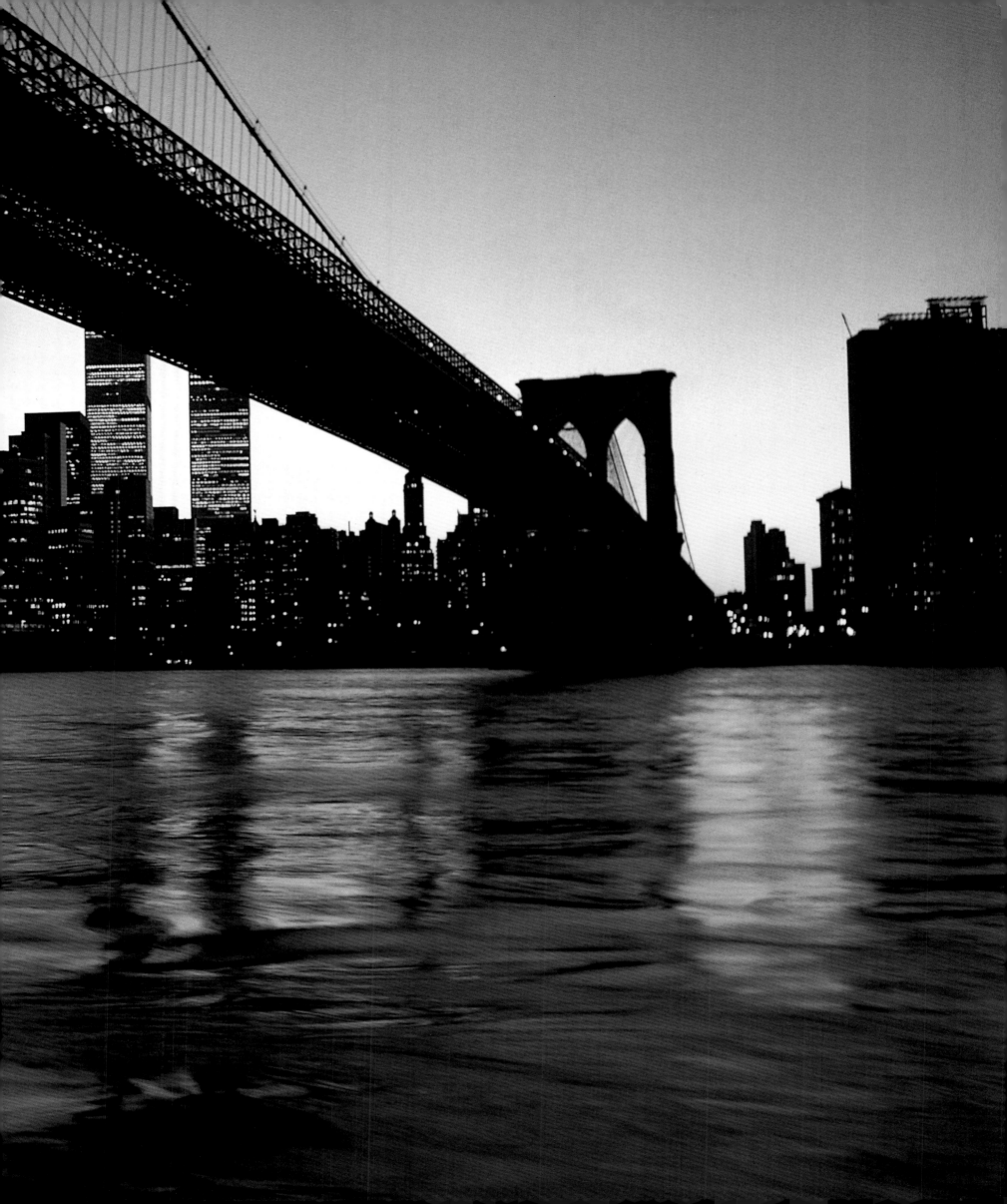

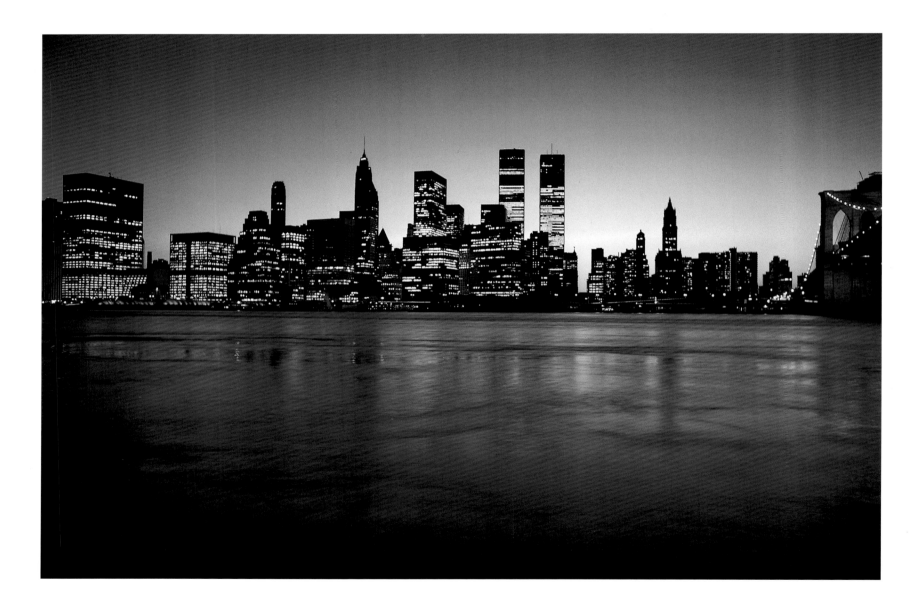

THE VIEW
LOOKING WEST

100

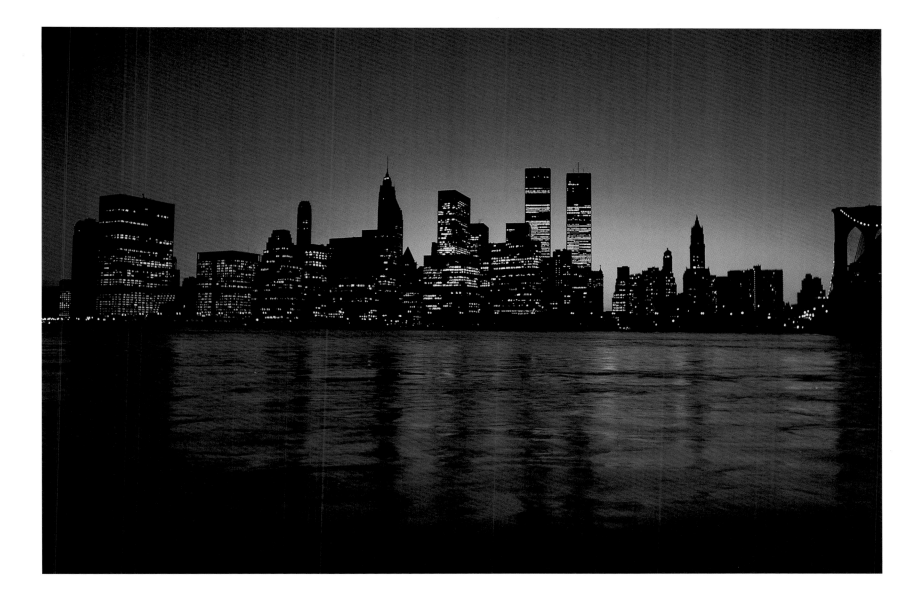

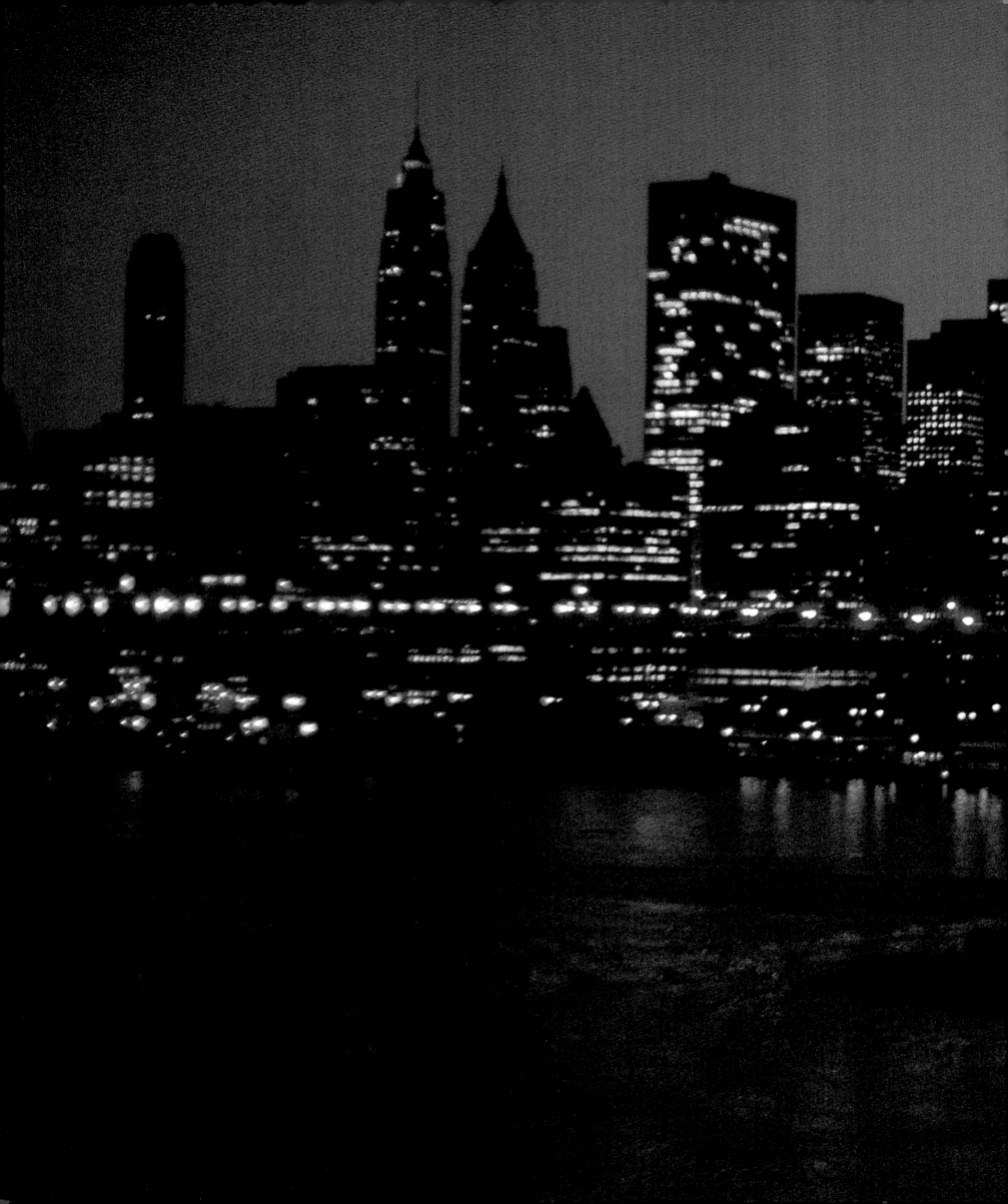

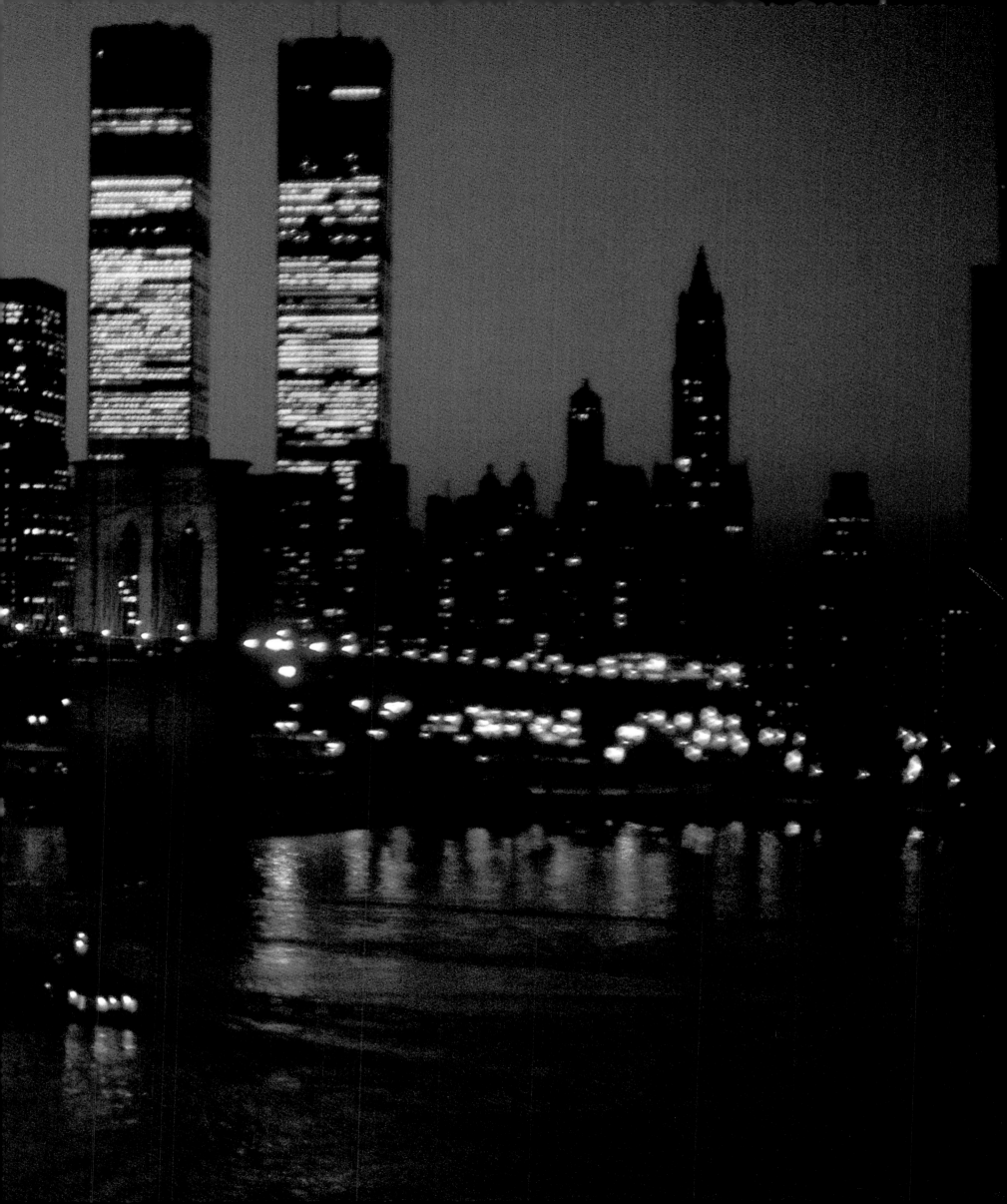

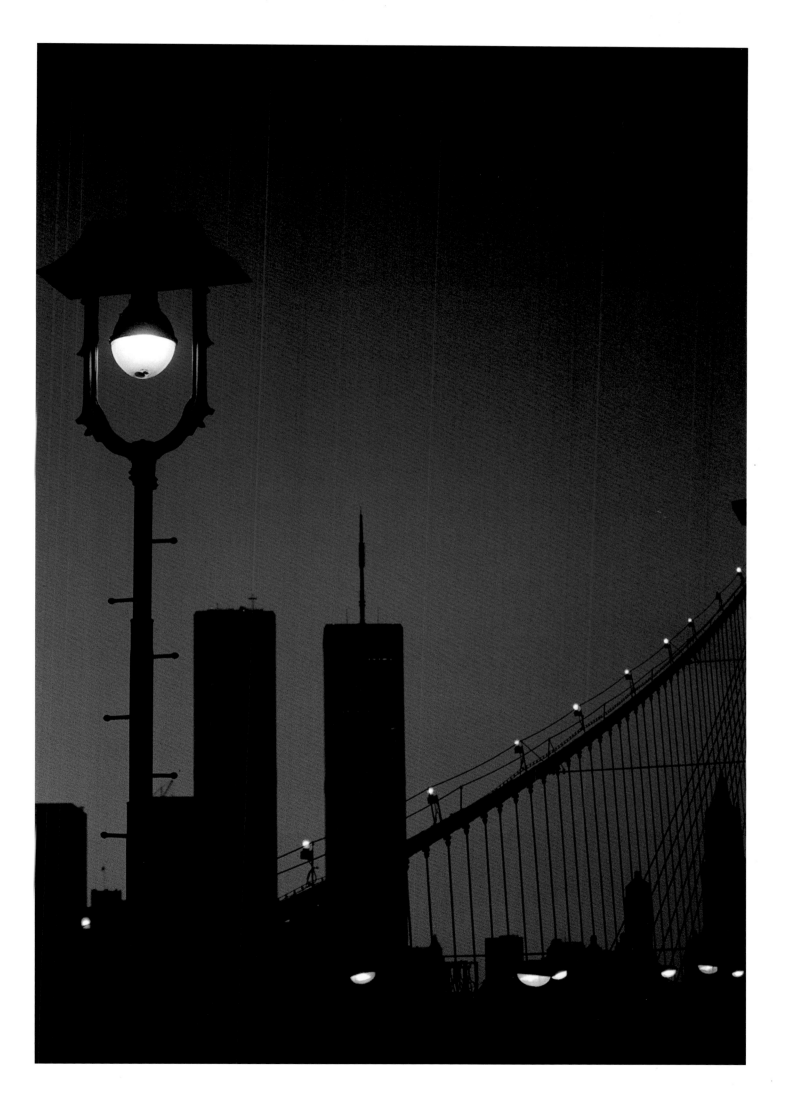

THE VIEW
LOOKING WEST

105

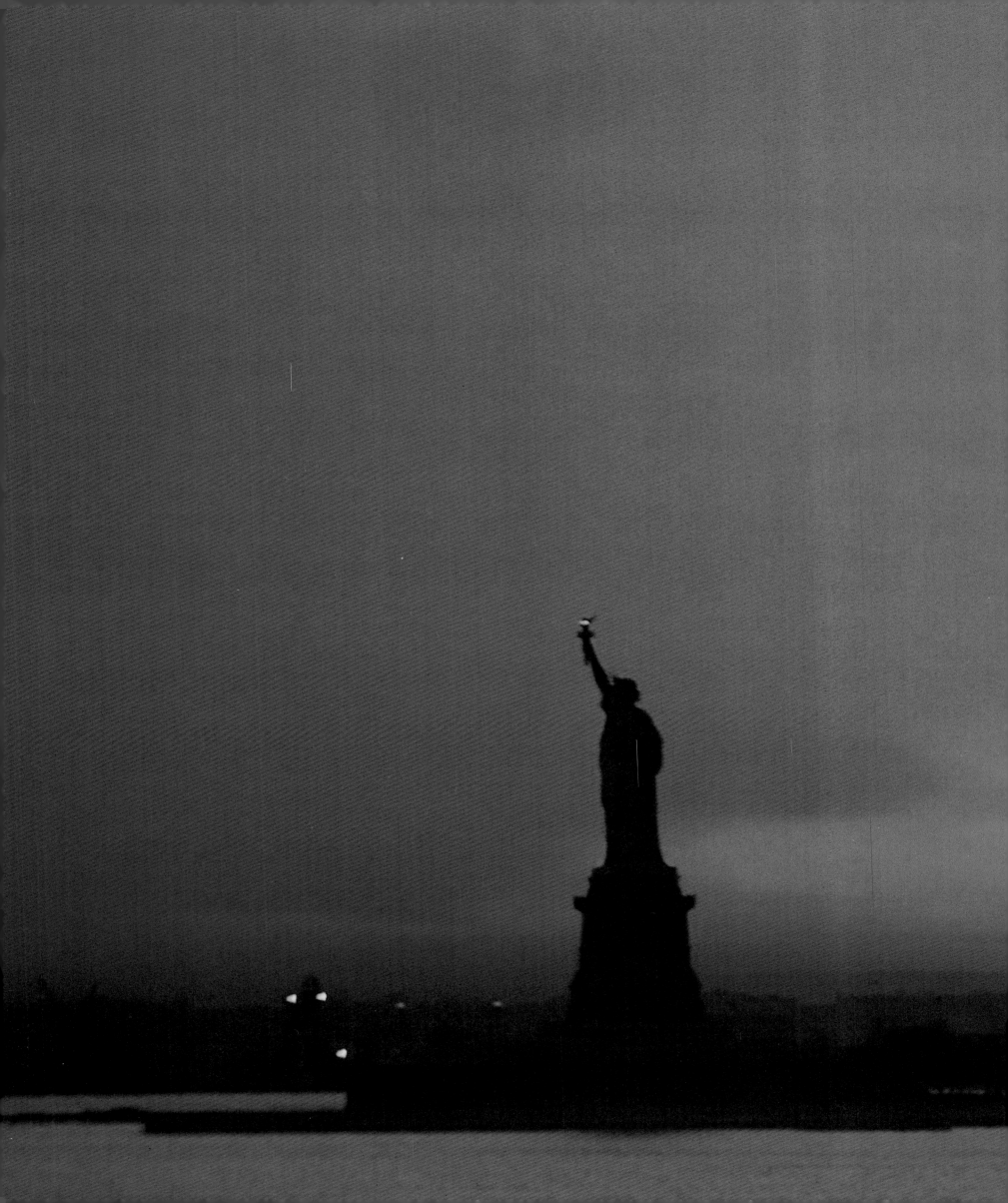

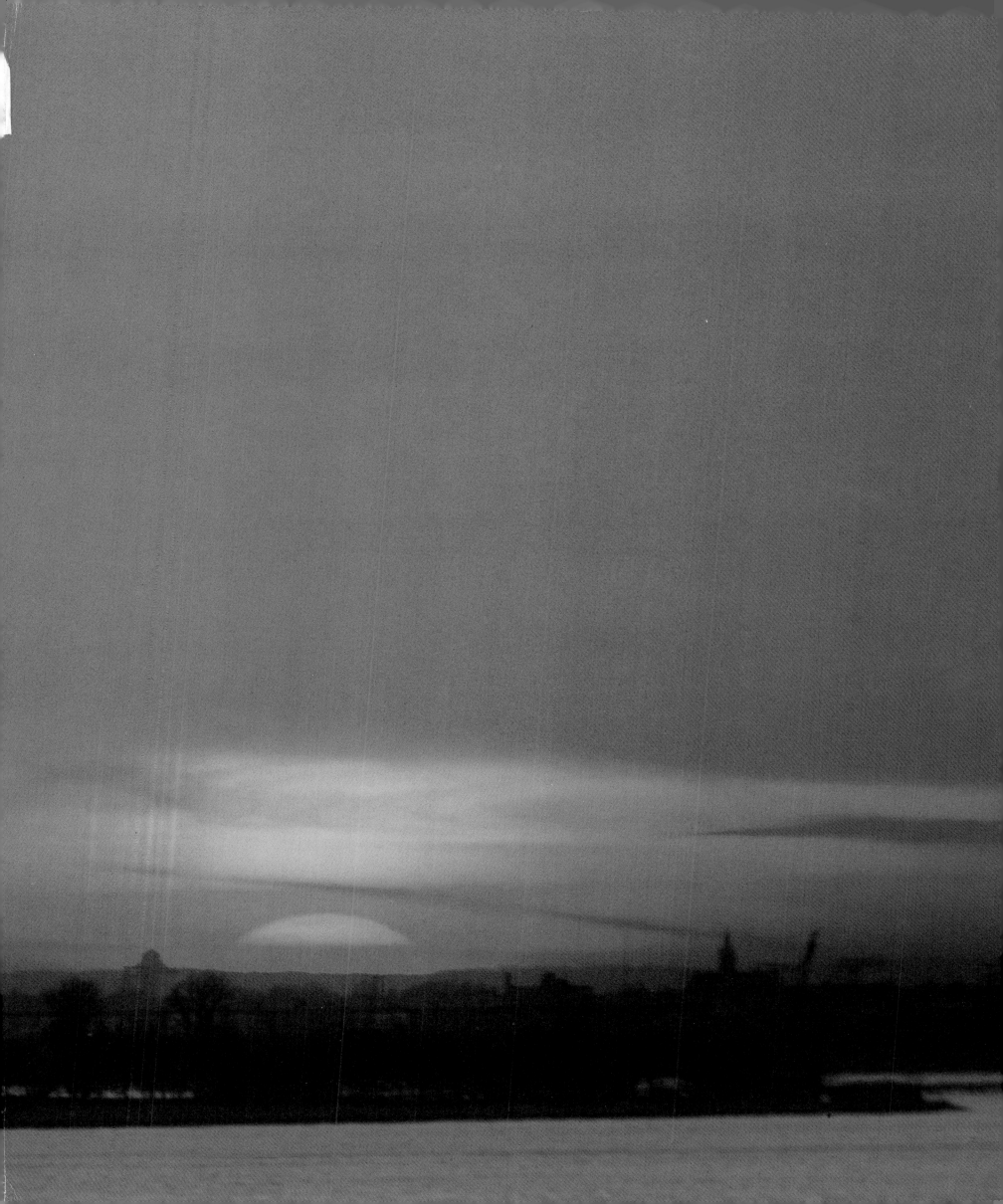

Editor: Susan Costello
Art Director and Designer: Julietta Cheung
Copyeditors: Marian Appellof and Miranda Ottewell
Production Manager: Louise Kurtz

All photographs in this book were
taken by © Sonja Bullaty and Angelo Lomeo
except the following photographs and
illustrations listed here:
Bettmann/Corbis: 15, 19;
Greg Martin/Corbis Sygma, 27;
Superman: The Man of Steel no.1, ™ and ©
DC Comics 1991. All Rights Reserved.
Used With Permission, 24;
© 2000 Condé Nast Publications, Inc. Reprinted
by permission. All Rights Reserved., 25.

Color separations by L. P. Thebault Company
in the United States of America.
Printed and bound by Paramount Printing
Company Ltd in Hong Kong.

First edition
2 4 6 8 10 9 7 5 3

Library of Congress
Control Number: 2001097223
ISBN: 0-7892-0764-8